GILA

GILA

I
RADICAL VISIONS

EDITED WITH A FOREWORD BY
MARY ANNE REDDING

INTRODUCTION BY
CHARLES BOWDEN

ESSAYS BY

VICTOR MASAYESVA JR. · JORGE GARCIA · PATRICK TOOMAY

DAVE FOREMAN · M. H. SALMON · MARY KATHERINE RAY · JOHN C. HORNING

PHILIP CONNORS · ALEX G. MUÑOZ JR · GUY R. MCPHERSON

MARTHA S. COOPER · REX JOHNSON JR. · SHARMAN APT RUSSELL

MUSEUM OF NEW MEXICO
SANTA FE

FOREWORD 7
Mary Anne Redding

ARTIST'S STATEMENT 9
Michael P. Berman

AN INTRODUCTION TO THE BEGINNING OF OUR FUTURE 11
Charles Bowden

SANCTUARY 15
Victor Masayesva Jr.

GILA: A PLACE OF RESURGENCE AND RENEWAL 19
Jorge Garcia

HEAVEN'S GATE 23
Patrick Toomay

WHITTLING AWAY AT THE GILA WILDERNESS 29
Dave Foreman

DREAMING THE RIVER 35
M. H. Salmon

THE EPHEMERAL WITHIN THE ENDURING 39
Mary Katherine Ray

EQUILIBRIUM 43
John C. Horning

A COMMUNION WITH SKY 45
Philip Connors

THE GILA WAPITI AND ME 49
Alex G. Muñoz Jr.

GOING BACK TO THE LAND IN THE AGE OF ENTITLEMENT 53
Guy R. McPherson

THIS WILD RIVER 57
Martha S. Cooper

CHANGE 61
Rex Johnson Jr.

BOX CANYON ROAD 67
Sharman Apt Russell

CONTRIBUTORS 73

FOREWORD

Mary Anne Redding

Is unmediated solitude necessary to begin constructing a biography of place? I am beginning to believe that it is. In working with Michael Berman on this book about the Gila Wilderness, I have had the pleasure to glimpse, now and again, the lives and passions of the photographer and many of the essayists who have written for this publication, discovering that many of their lives are filled with long periods of solitude and wandering. Tethered to my work in Santa Fe, I envy their freedoms until I remember that some of us must pull a project like this together and that I am grateful to have had time to spend, however mediated, with their images and words.

Composing a full biography of the Gila Wilderness in all its 3 million plus acres of untrammeled (and not a few trammeled) lands may be an impossibility, just as a biography of any one individual's life is invariably incomplete, even with the subject's full cooperation and that of its familiars. But we have tried and, to an extent, succeeded in introducing the reader to multiple facets of the Gila in all its complexity and diversity through the words and images of those who have an enduring engagement with the place, not by defining or prescribing but as an ongoing process of encounter and experience. The photographs are not illustrations for the text, nor are the various essays attempts to explain the images. Rather, taken alone or together, they provide interrelated points of illumination on the Gila as well as on the cultural perspectives, environmental concerns, and notions of place and belonging of each of the essayists, listed here in alphabetical order, who generously poured out their passion for the Gila in response to Michael's request to write from the heart: Sharman Apt Russell, Charles Bowden, Philip Connors, Dave Foreman, Jorge Garcia, John Horning, Rex Johnson Jr., Victor Masayesva, Guy McPherson, Alex Muñoz, Mary Katherine Ray, Dutch Salmon, Martha Schumann Cooper, and Pat Toomey.

One of Michael Berman's gifts is knowing how to give back. It is our hope that this book will not only bring the art and environmental communities together in an appreciation of the Gila but will also act as a catalyst for raising awareness and funds for much-needed support of various causes in what is left of the wilderness areas of New Mexico. As the first designated wilderness area in the United States, the Gila was set aside in 1924 as an example of the rapidly disappearing wildlands; now, nearly ninety years later, even fewer wildlands are left in New Mexico, the West, or anywhere on the planet that have not been mediated by human intervention. In the final years of wild places, the Gila remains threatened but largely undeveloped, even though its use by humans has a long and rich history both exemplary and abusive. It is Berman's wish that this work be part of a strategy for the continued rewilding of the Gila in the face of complex, evolving economic, political, and environmental concerns that have brought us face-to-face with a more rapid increase in global warming and species extinction than predicted only thirty years ago. In both photographs and words, this book illuminates what has made the Gila valuable historically and why it continues to be of critical interest today.

As is every project, this one has been made possible through the contributions of many people: Ed Ranney and the New Mexico Council on Photography, who early on supported our ideas before they were fully formed; the staff at the McCune Foundation: Wendy Lewis, Norty Kalishman, and Owen Lopez, who allowed us to bounce a few wild ideas across the table and bounced them back, saying, "Let's make this happen"; the Santa Fe Community Foundation for facilitating funding; Connie Adler of the Adler Foundation and Eleanor Wooten of the Wooten Foundation, who, excited by our written proposals, continued their support of environmental wilderness efforts with their assistance on this project; Christie Mazuera Davis and Patrick Lannan at the Lannan Foundation for their ongoing support of Berman's creative talents; the staff at the New Mexico History Museum/Palace of the Governors for adding Berman's Gila Portfolio to the permanent collection of the Photo Archives; Anna Gallegos, Mary Wachs, David Skolkin, and Renee Tambeau of the Museum of New Mexico Press—they truly know the hard work behind their seemingly magic wands; and those who purchased portfolios of Berman's photographs in support of this book project, either to add to their own collections of landscape photographs or in support of environmental organizations; and, most importantly and from the heart, Michael Berman and I would like to thank our partners in life, Jennifer Six and Roger Atkins, without whose belief in both the radical visions and enduring silence none of this would have been possible.

ARTIST'S STATEMENT

Michael P. Berman

The Gila is nestled at the nexus of four great ecosystems in the southwest corner of New Mexico. It lies at the end of the Rocky Mountains after they slide down the North American continent like a glacier for three thousand miles just before they break up into an archipelago of small ranges floating in a sea of grasslands. A couple hundred miles to the south, the Sierra Madre Mountains rise up, serrating Mexico for another two thousand miles. To the west lies the Sonoran Desert with its giant saguaros, and to the east spreads the Chihuahuan Desert, a minimalist dream of small ranges and desert grasslands.

The Gila River courses through this land. The water descends into a ring of volcanic ranges that circle from the Tularosa Mountains across the T-Bar Grasslands and the Plains of San Augustin in the north over to the Black Range in the east. The mountains swing west across the Mimbres Valley to the Piños Altos Range, and then through the Diablo Range north into the 10,000-foot peaks of the Mogollon Mountains. Over 650 miles of streams flow through this circle of mountains, forests, and canyons. The Gila River is the last undammed river in New Mexico.

The heart of the Gila is wilderness. The great American conservationist Aldo Leopold conceived the modern concept of "wilderness" here. It was in the Gila that he learned the significance of fire and water, predators and prey, and the marvels of large untrammeled landscapes. Leopold convinced the U.S. Forest Service to designate the Gila as the world's first wilderness area on June 3, 1924, and it was recognized as the first wilderness of the National Wilderness Preservation System when the Wilderness Act was signed into law by President Lyndon B. Johnson in 1961. Due to these and later preservation efforts, the Gila is still a wild place.

AN INTRODUCTION TO THE BEGINNING OF OUR FUTURE

Charles Bowden

Istand with coffee in the morning cold, the sun warms my face and I know if I just cross that river I will enter ground that has become a dream as my people chew up the planet with their hungers. Once the place felt huge; now it seems an island in a storm of destruction.

The ground I stare at has become the place of questions, not answers.

New Mexico has the site of the first atomic bomb blast, Trinity.

Here is a question: Which place has created more security for the American people, Trinity or the Gila Wilderness? Both were created by very intelligent and patriotic Americans in an effort to save our souls. Both were planetary firsts when they came into view. Both have endured as dreams on the edge of everyday life. But both cannot be the future. Nuclear weapons and wilderness write two different endings for *Homo sapiens*.

Whatever answer is given to this question exposes who we are and what kind of a world we will help create.

The Gila is a place that became an idea, and the idea became a path seldom taken in the years following its eruption into the cultures of people. The idea of wilderness meant everything, or nothing. For believers it meant leaving a patch of earth alone, spared roads and what human beings call development. It was to be the place never turned to account, the place humans could visit should they wish to remember the web of life that made them and made the other living things that never lined up to the call of the factory whistle.

For people, the Gila has always been a new beginning. There were the Mogollon people, then the in-migration of Apaches, the Spaniards arriving for the mines, the Mexicans claiming the property of the defeated Spanish empire, then the Ameri-

cans with railroad dreams—a fantasy destroyed by the ground itself and creating the need for the Gadsden Purchase. And after settlement came a miracle: Aldo Leopold proposing and getting, in 1924, the first wilderness area on this planet fashioned by human beings for other nations of animals and plants.

On the ground, the place seems to have escaped the ravages of American civilization. This is an illusion, but still a powerful illusion, because so much of the devastation of the United States has been spared the Gila. I believe in this illusion, even though I know the sky above is altering with the breath of climate change, that the state itself is a nuclear sewer economically dependent on an industry of death, and, just to the south, Mexico is breaking down and sending human waves north as people flee in order to survive. The United States population is swelling like a balloon—in 1924, when the Gila Wilderness was declared, there were 114 million Americans and the world population was 1,184,000,000. For every living thing in the Gila, a firestorm is coming as human numbers increase and the land base for the other living things shrinks.

I don't have any problem with the future; this has been my country since the day I was born. But I intend to look out for my own, and I come from a very extended family. I have no choice but to defend the Gila, just as I have no choice but to defend the poor Mexicans streaming north to escape poverty and death. Same, too, for the wolf now freely roaming the Gila, a necessary act to honor Aldo Leopold, the person who saw the error of his ways and saved the Gila country. He's dead; now it is our watch. And this watch continues as long as time goes on or until the planet regains its health and sanity.

It is possible to tote up the biological riches of the Gila, and it is easy to make strong statements of the Gila's benefits to the human spirit. But I leave this to others. If the planet is to live, there must be more places like the Gila. If humans are to persist, there must be more places like the Gila. The place happens to be beautiful and large. But that is not why it is important. The Gila shows us the way to go home. I know of no government on earth that can make that claim.

What Aldo Leopold created was not an act of generosity but of sanity.

This book is a manual for reaching such sanity.

I am on the road a lot, and I hear despair. I will have none of that. The birds in the morning light do not despair; the sun at midday does not despair; and the wine in the cool of evening when I sit and suck in life itself, well, hell, at those moments I do not despair. Life will persist. The only question is about us: will we do the right thing. If we don't, we will cease to matter as the other life-forms of our planet seize the reins from our useless hands.

The Chihuahuan Desert traps water into landlocked basins, coats itself with creosote and lens of grass, and, as the ground creeps upward, the grass takes more and more; and then along the Mimbres apple orchards dot the banks, and rising more, the piñon and juniper start to surrender to ponderosa; Spanish place names get erased by later American invaders, and everywhere sleep the relicts of Mimbres culture and old Apache campfires; then over the big ridge and from the crest the Gila country unrolls, and down to the forks where pine and cottonwood line the clear stream tumbling over a rock ledge; and then comes the place past all the words of history, a dictionary in motion, mile after mile of land we cannot read. Up in the mountains Douglas fir, blue spruce, everywhere deer and elk and bear and lion, and now, the returning hungers of the wolf.

The wind is up; the ghost of a moon hangs in the blue sky over the ridge line.

The leaves are down, winter nears, and the Gila awaits snow that feeds the rivers and the silence that closes out my world.

There is not much to say about a place that says a lot and has its statements fall on deaf ears.

SANCTUARY

Victor Masayesva Jr.

When life becomes chaotic, there is a pilgrimage available to us as a community. In Hopi, it is referred to as *Katsi hepwisa*, also *Katsi hepya*.

Sociologically, the movement away from chaos has been described as a migration, or, in Hopi terms, fleeing from *Koyanisqatsi* through organized movement, *Katsi hepya*. In the past it would have been Hopi clan migrations away from corrupt civilizations into unoccupied spaces.

Archaeological findings support *Katsi hepya* as migrations from Meso-America to northern Mexico and further north carrying along rain-making ideologies, significantly after AD 1200. Going further into the past, archaeological, genetic, and paleoclimatic dating proposes migration patterns starting 14,000 years ago across the Bering land bridge. The common instinct for these migrations must have been a search for a better life, *Katsi* (life), *hepya* (looking for). Whether it was following the game animals, looking for larger plant food reserves, or the search for fertile areas for cultivating seed stock, the earliest travelers' patterns of movement were in search of a better life.

For the Hopi, it seems to have been a matter of seeking sanctuary from the influences of Koyanisqatsi, idealistically a sanctuary where Hopi Kati, peaceful living free from weapons of destruction and human insensitivity, could thrive. However, over the years of Hopi migrations Koyanisqatsi reappeared again and again, leading to more movements until fewer sanctuaries became available in a landscape increasingly populated. Moreover, these early settlers were becoming increasingly protective of their territories. Where to now?

One thing that the *Hisatsinom* (ancient ones) were certain of was that this continent was under the stewardship of a spirit being and that there were other people

over the horizon and others following in their footsteps. This continent and this landscape were occupied and known. This consciousness is ubiquitous in the origin narratives of indigenous populations but not fully acknowledged or understood by Western scientists and their American audiences. What is left of wilderness if we accept this perception of a pre-trammeled wilderness?

Those privileged to access these areas today seem to embody this idea of "wilderness" as an individual experience and not one described by community. Wilderness preservation over the years seems to be the preservation of what "I" like about myself. It is a narcissistic, egocentric response to the remote expanses remaining on the continent. It seems to be an individualistic American value imposed on an ecosystem, quantified materialistically as "wilderness." As such it has been a wilderness for less than one hundred years with the passage and protections provided by congressional acts. What was it before 1924?

Mangas Coloradas, Victorio, and their families (Mimbrenos, Warm Springs Apaches) lived in the Black Range and Gila River tributaries in the 1800s, and it is doubtful that they felt they were ensconced in wilderness. It is hard to imagine that the soldiers carrying the American flag in these mountains and valleys were on a nature outing. They were murderously pursuing the wildness and savagery impeding their materialistically driven civilizing techniques. The flag that fluttered over these mountains and valleys to capture and remove the wilderness occupants was certainly not protecting current wilderness initiatives. During a visit to appropriated Chiricahua homelands, my Apache friends Silas Cochise and Oliver Enjady lamented the fact that the mountains, rocks, and animals would not hear the Apache language or the laughter of Apache children in these places anymore.

Certainly the Apache groups traveled over this area and into northern Mexico. Their astounding endurance and epic journeys over this landscape are well documented in U.S. military records. But their own story resides in seeing this grassy landscape as an ocean with the islands serving as provisional stopovers, islands now named Gila Wilderness, Black Range, Dragoons, Chiricahuas, Sierra Madre, and others.

Beyond the well-documented history of the Apaches and the United States in this area, the archaeological and biological evidence provides a compelling story of prior occupation, supplementing the oral histories of present Pueblo communities that stretch from the Rio Grande Valley to the Zuni and Hopi areas. The Gila and Mimbres areas were settled by farmers from around AD 200 to AD 1200, after hunting and foraging groups had passed over the land, supplementing their food gathering with corn cultivation beginning around 2000 BC prior to the Classic Mimbres period around AD 1100. The Hisatsinom (Anasazi) had occupied and cultivated corn

in the San Juan Basin areas, which were abandoned by the 1300s as climate changes affected settlement patterns. But more than that, these last great movements of people were driven by a consciousness of other communities on this continent. Celestial events, including, most markedly, the supernova of 1050 (*ponochona*) propelled these Hisatsinom to evaluate their destinies: their identities, their beliefs, and their final destinations. From Pueblo oral histories it is evident that these final movements ended in the historic sites first "discovered" by the Spaniards.

Certainly there was a lot of movement between Hisatsinom, Hohokam, Mogollon, Salado, and Sinagau people. There were exchanges because of their common mother language, Uto-Aztecan, which, at its greatest extent, ranged from Honduras in Central America to Idaho in North America. Recently, the idea that the Uto-Aztecan language was the common language of the travelers has been linked to DNA research. Revealing DNA samples from Haplogroup C were found in Kawestima (Kaibab Plateau) from the Basketmaker II period and the Mimbres area, also concentrated in west-central Mexico among Cora, Huichol, and Nahua speakers.

Therefore, we have to encompass ecosystems, and the organic and spirit communities encompassing this word *wilderness*. We need to go beyond the short history of a politically, ethnocentrically driven terminology of wilderness to include wilderness as a broader cultural landscape.

As a baseline, I would begin by referencing the short history of the Hopi people over 10,000 years in our current communities, during which time our relationship with the land has become more complex and interwoven with spiritual connections. As we see the changing environment affect our farming traditions, I notice that the Western scientific perspective views this environment as a landscape removed from human biological systems. Inherently, science works from the perception of an objective reality that does not see an evolutionary connection from plant to humans. It does not allow for an inclusive perspective involving plant, animal, water, minerals, earth, light, clouds, celestial bodies, spirits, and humankind. It does not allow for a landscape inclusive of socioeconomic, political, agricultural, biological, and reproductive energies in addition to spiritual phenomena. It is within this context that the Katsinas appear to us, in our plazas where they come bearing gifts for everyone. They come with learning tools for our children and food raised and prepared by Katsina spirit families and communities. They embody in paint, dress, song, and spirit various ecosystems, symbolized by cotton cloth kilts; eagle, parrot, and feathers of various birds; skins of herbivores and carnivores; by mountain and valley plants, by different earth paints over their arms, legs, and bodies. Their visages are clouds, lightning, rain, snow, and heat, and they communicate by singing songs of a peaceful order of living.

These Katsinas came to the Mimbres people as well. This is the difference between the indigenous perspective on the landscape and that of the colonists.

Typically now we go to springs and water sources, the mysterious and melodic breath of other living organisms and subterranean communities, to reflect on and reconnect with the knowledge of our affinity with a larger community. We go on pilgrimages to these water sources and to eagle and animal homes to look for life. We go to plant communities for strengthening the body. We go to past ancestral homes in canyons, mountains, and plains to invoke the pity of ancestors for our continued health and well-being. The Gila Wilderness has this capacity, and we must continue to learn from this source.

GILA: A PLACE OF RESURGENCE AND RENEWAL

Jorge Garcia

*R*esurgence and *renewal* are two words that reaffirm our covenant with life. All living things make the journey from inception to resurgence. Once resurgence takes place life is renewed through the intent of life itself. Life then emerges from the spark of life that brings us together in the harmonious creation of all things. The old Mexicans identified the spark of life with the essence of *xihutecuhtli*, the lord of fire, the lord of volcanoes, or literally, "the spark of life that defines time."

The creeks, canyons, steeps, mountains, grasslands, and rivers of the Gila still preserve this profound sense of the spark of life through their sense of belonging and antiquity. This place is still regarded by the descendants of the Chichimecas from northern Mexico and the southwestern United States as their ancestral home, their place of resurgence and of spiritual renewal. A place where the heavens and the depths of the world came together millions of years ago in calderas that have carved out the ridges that are now the spine of the Gila's mountains.

Every step in this place needs to be taken with care so as not to disturb the peace of the land. The almighty trees that safeguard the canyons and the slopes lay across as if determined to stop those who quietly move in to take the spirits of the living away, to hang it as a trophy to manifest destiny, the determinant of man's privilege. The old age rings of the fallen trees seem to remind us that people are resting in this place, waiting for their turn to walk across from east to west, the sacred path to life across the Milky Way.

Caves that once protected the ancient peoples of this land overlook the area as if making sure that nothing disturbs the peace of the spirits of people who long ago ceased to call this place their home. The caves are the source of resurgence and a window to the times when men lived within the entrails of mother earth, a time recorded in the rocks with symbols that we see but fail to understand, stone messages that remind us that life existed thousands of years ago and that life must continue for our future generations to enjoy. The earth buildings remind us that we are the children of the earth and, as such, we must honor our place so our descendants will know that we knew how to take care of sacred land.

Over its long history, the Gila mountains have seen the activity of people who reaffirmed their connections with the living and the dead by entering the womb of mother kiva to commune with "that from which we live," the essence of spiritual belonging known to those who maintain a close relationship with a place.

In recent times, the Gila served as a home to the indomitable Apaches, the "edge of the mountain people," the people who bring down the spirits from the mountain, those who moved through these mountains and valleys, as if they were magical places that tested their strength and cleverness to survive.

Later, the Mexicans migrated back to the Southwest from central Mexico to their place of origin, Aztlan, the mythical place of the people. The Mexicans settled close to the rivers so they could plant chile, corn, and beans, which provided them with the nourishment they needed to continue their journey in life. As the Mexicans settled around these mountains, they continued to honor life by preserving ancient traditions that incorporated land, water, wind, and fire. This land invited people to stop time and enjoy life in a way particular to this place, a place known as the "land of tomorrow, *la tierra del mañana donde no pasa nada.*"

Then miners and ranchers came, resolved to tame the land and mine the entrails of the earth. The new concept of life and use of land did not take into account its sacredness. Now it was a place that could be sacked for the benefit and recreation of individuals. The newcomers were resolved to change the rules so the land could give more than its beauty could afford. No one knows this better than the Mexican wolves that were driven out to safeguard manifest destiny against creatures that were part of the landscape.

Mexican wolves, like the Chichimecas, had roamed this land from time immemorial. In fact, some believe that the wolves are the spiritual brothers of the indigenous People who roamed the land. The Mogollon, the Mimbres, and the Apaches learned to share this place with these predators to maintain the delicate balance in the Gila mountains.

But to protect the interests of the newcomers one by one the wolves have been chased and killed regardless of their right to exist. It is unfortunate that Mexican wolves do not speak, for it would be great to ask them: How does it feel to be strangers in your own land? What does it feel like to live in an area as big as the Gila knowing that there is no place to rest and that in an instant your companions might be shot and killed, leaving you with a sense of loneliness, uncertainty, and dispossession?

I am not sure what their answer would be, but I am sure that when they get hit by bullets of unseen cowardly shadows they ask, "Why are you doing this to us? What have we done to you that elicits a break in the covenant of life between man and the animal kingdom to which we both belong? And why are we deprived of a land that our ancestors inhabited long before you came to our land?"

No one has grieved for the Mexican wolves more than Aldo Leopold (1887–1948), who, after seeing a wolf dying from a shotgun blast, expressed the following thoughts in his memoirs:

> We reached the old wolf in time to watch a fierce green fire dying in her eyes. I realized then, and have known ever since, that there was something new to me in those eyes...something known only to her and to the mountain. I was young then, and full of trigger-itch; I thought that because fewer wolves meant more deer that no wolves would mean hunters' paradise. But after seeing the green fire die, I sensed that neither the wolf nor the mountain agreed with such a view.

Regardless of whether the wolf or the mountain agreed, the wolf had been killed without understanding why. As the fire in her eyes died, she probably thought about what would happen to her pack. Her little brother, the human, had forgotten that long ago an agreement had been made, not only to respect the covenant of life but also to protect the place that had been sacred to those who came before them.

The Gila mountains are a monument to life itself. They are a refuge to wildlife that still disregards invisible borders never known to those who cross the ridges free like the wind. Their deep canyons and standing armies of junipers still guide us through the Gila. Hopefully we let ourselves be walked through the forest to appreciate the covenant of life and maybe, just maybe, one day we'll restore our ties with the Mexican wolf and ask him to lead us to the place of resurgence so we can renew our spirit again in the Black Mountain, so we can become one with the land again.

In that sacred land, we will ask if one day we may return to Chicomoztoc, the land of the seven caves, the place of resurgence, the place of spiritual renewal, the

land of the ancestors, the land of our brother the Mexican wolf, the animal that, as Henry Beston expressed, "shall not be measured by man. In a world older and more complete than ours they move, finished and complete, gifted with extensions of the senses we have lost or never attained, living by voices we shall never hear. They are not brethren, they are not underlings: they are other nations, caught with ourselves in the net of life and time, fellow prisoners of the splendor and travail of the earth."

To achieve resurgence and renewal again, we must protect beauty. We must protect life. We must protect the Gila, the place of our physical resurgence and of our spiritual renewal. *Ometeotl.*

HEAVEN'S GATE

Patrick Toomay

Walking the Gila Wilderness can provoke an imaginal onslaught. For me, ghosts are among the clamoring presences—a veritable horde of them—swirling amidst the Gila's scrub and tuft. Ghosts of mounted, blanket-wrapped Apaches, who, though never settling permanently in the area, crisscrossed it for hundreds of years, camping on rocky bluffs overlooking hot springs, where even today their knappings and fire rings can be spotted by observant hikers. Legend has it that Geronimo himself was born at the headwaters of the Gila River, one of three rivers that converge in the bottom of the volcanic caldera that cups the park, at the foot of the Gila Cliff Dwellings.

Ghosts, too, of gnarly old ranchers like Quentin Hulse, who sought to wrestle a living from running cattle and outfitting hunters from his home deep in an obscure canyon where he lived for fifty years—until 2002, the year of his death—without electricity, plumbing, or running water. Ghosts, too, of the shabby Anglo miners who came and went after extracting their ore and of the Mimbres River Mogollon people, whose distinctive pottery is so striking that it may as well have been dropped into the caldera from another planet.

The Mogollon people have been gone since AD 1200. Gone with them are the equally mysterious Cliff Dwellers, who, it is suspected, migrated further south, to the arid plains of central Mexico, where they fathered, among other tribes, the contemporary Chichimecs. Interestingly, it was to the Chichimec pueblos that endangered Mexican gray wolves retreated after being virtually exterminated from North America during the early 1900s. From there, in the late 1970s, the U.S. Fish and Wildlife

Service retrieved pairs of wolves to be bred in Carlsbad before being reintroduced into the Gila, but the program has been plagued by cultural intolerance. Sadly, despite their scientifically demonstrated ecological necessity, wolves continue to be shot by ranchers so that they now, in 2011, number only forty-two when it was expected that upwards of one hundred would be reestablished in their preserve. Resonant with the fate of the wolves is the ongoing slaughter along the nearby U.S./Mexico border, where, since 2008, in the drug-war ravaged environs of Juarez, some 7,200 people have been murdered.

So ghosts of every kind are here, swirling among the volcanoes; it seems to me that they, along with the land itself, are begging us to expand our vision of the region and thereby calm the turbulence. How? By taking into account notions of sacred topography going back to prehistory. By considering the earliest north-to-south human migrations—the descending pulses that ended up populating the Western Hemisphere—as a kind of complement to the predominately lateral east-to-west drive for American manifest destiny, which came much later and with which we are all too familiar. Maybe, with this revisioning, we can see more clearly what is represented by this collective north-to-south, east-to-west flow of animals and people throughout the millennia. Maybe we can finally realize the promise inherent in the living "cross" that exists in the heart of our country and more fully appreciate the Gila's privileged position at the foot of it, as gem among telluric gems.

Photographer Michael Berman, who has prowled the Gila for thirty years, likes to tell neophyte photographers that the key to successful landscape photography is learning to "let the land guide you." In making this assertion, Berman betrays the almost indigenous sensibility at the root of his Gaelic heritage; one wonders if it wasn't precisely this sort of guidance that provided the compass for the earliest migrants. Imagine a band of them setting out from Burkhan Khaldun, a mountain in northern Mongolia deemed sacred by Mongols for millennia—an area where, echoing the Gila, hot springs effloresce at the convergence of three rivers along a massive rift. Imagine them setting off for the land bridge that formed across the Bering Strait 12,000 years ago, just as, on the other side, receding glaciers opened up a pathway down the inside of the Rocky Mountains. Flowing south down this passageway, following the guidance of their internal compasses, these early people would have been led to the first of two geologic nodes whose abundance, familiar from their homeland, would have marked places of haven for them during their extended journeys.

These nodes are characterized by the presence of volcanic calderas. Calderas are formed when the magma chamber beneath a volcano empties during an eruption and the floor of the volcano collapses. The total area that collapses may be hundreds

or thousands of square miles. Over time, the rim of the original volcano erodes so that its distinctive shape may no longer be obvious in the landscape, although its deep structure is still present.

Today, it is not widely known that of the twenty largest calderas on earth, nine reside within the continental United States, and three of these are situated within the southern Rocky Mountain volcanic province, an area that includes the Gila and its caldera. Although the Gila Caldera does not appear on the top-twenty list, it is surrounded by super volcanoes that do. Abutting the Gila Caldera to the west is the Bursum Caldera (no. 13). To the east is the Emory Caldera (no. 12). To the northeast is the Socorro Caldera (no. 15). Unlike its neighbors, the Socorro Caldera hosts a resurgent magma dome. Of extant U.S. resurgent magma domes, Socorro's dome is the most active and immediately threatening after Yellowstone's. Swelling under the Yellowstone Caldera (no. 10) is a reservoir of molten lava the size of the Irish Sea. In my fantasy, Yellowstone and environs would comprise the first geologic node to which early migrants would be compelled, while the southern Rocky Mountain volcanic province would be the second.

In Western culture, volcanic regions have long been associated with hell. However, as British classical scholar Peter Kingsley reminds us, Parmenides, the early Greek philosopher considered the founder of Western rationality, received his insights from meditating in hellish places, such as Sicily's Mt. Etna volcano. In fact, Empedocles, Parmenides's disciple, who lived in Sicily, was often drawn there. Reportedly, he ended his life by jumping into Etna's roiling core. For me, a symbolic understanding of Empedocles's death illuminates the worldly accomplishments of these two pillars of philosophy, for together they demonstrate the efficacy of the *conscious* fusion of human thought with the power inherent in the earth. So, too, does the work of Florentine poet Dante Alighieri, whose *Divine Comedy* presents one of the last great integrative cosmologies in the West by situating both individual and human society within "a great divine image."

Not incidentally—as literary critics are quick to point out—Dante makes extensive use of the number three in his epic:

> There are three books to the *Comedia* itself, each with thirty-three
> cantos.... Important events tend to occur in cantos that are multiples
> of three....The poem employs a unique, interlocking rhyme scheme
> that allows the number three to literally permeate the whole of the
> work.... Nine circles—three times three—compose the whole of Hell's
> organization....Three separate ferrymen are required for passage across

three distinct rivers.... (Richard Lansing, ed., *The Dante Encyclopedia*, Routledge, 2000)

Three distinct rivers. As in the bottom of the Gila Caldera, where three distinct rivers converge at the foot of the Gila Cliff Dwellings. As at the base of Burkhan Khaldun in Mongolia, where three distinct rivers filigree into the surrounding countryside. As at Three Forks, Montana, just north of Yellowstone, where three distinct rivers come together to form the headwaters of the Missouri. Here, the earliest Asian migrants stampeded bison off bluffs for food. Here, caves hold evidence of their habitation 12,000 years ago.

The river trinity at Three Forks is situated on the east side of the Continental Divide. On the west side, roughly the same distance away but a little further north, is a place where three different kinds of trees are growing from the same spot. These two trinities, of rivers and trees, are complemented by a third, one of mountains. Splitting the distance between the river and tree trinities, situated in the heart of Glacier National Park, Triple Divide Peak is North America's hydrologic apex. The Great Divide and the Laurentian Divide meet at the summit of the peak, and all water that falls at this point can flow to the Pacific, Atlantic, and Arctic oceans, making it the only place on earth whose waters feed three oceans.

That such telluric triads have theological implications was fully realized by Dante; less clear in his apprehension was a later "poet"—the physicist J. Robert Oppenheimer, father of the atomic bomb. Since uranium is a key component of magma, one might expect Oppenheimer at some point to have made the link. After all, it was Oppenheimer who selected Los Alamos, which sits on the side of the Valles Caldera, once the second largest volcano in the world, as the place to develop the bomb. And it was Oppenheimer who named the place of its detonation, which sits near the Gila directly atop the Socorro magma dome, Trinity Site. Yet as far as I know, Oppenheimer never made the connection.

However, it is clear that he *was* intuiting something. When asked by an army general if he had chosen the name Trinity Site because it was common to rivers and peaks in the west and would therefore not attract attention, Oppenheimer replied that he had not done so on that ground: "Why I chose the name is not clear, but I know what thoughts were in my mind. There is a poem of John Donne, written just before his death, which I know and love. From it a quotation: 'As West and East / In all flatt Maps—and I am one—are one, / So death doth touch the Resurrection.' That still does not make a Trinity. But in another, better known devotional poem Donne

opens, 'Batter my heart, three person'd God;—.'" (John Moriarty, *Dreamtime*, The Lilliput Press, 1999)

In contrast to the lushness of the northern node, which includes Yellowstone and Glacier, with its trinities of rivers, mountains, and trees, the southern node, which includes the Gila and Trinity Site, is a harsh, arid land. In fact, Trinity Site is located along a corridor so desolate that early Spaniards, finding it without water and subject to deprivations by Apaches, called it the *Jornada del Muerto*—the Journey of Death. This hellishness extends to the Gila, with its three distinct rivers and its three massive calderas. Yet the dizzying descent to the caldera floor yields a deceptive serenity. Here, the Old Testament story of Jacob is instructive. Resonant also is the surfeit of trinities with which Dante suffused his *Inferno:*

> And Jacob went out from Beersheba and went toward Haran. And he
> lighted upon a certain place, and tarried there all night, because the
> sun was set: and he took of the stones of that place, and put them for
> his pillows, and lay down in that place to sleep. And he dreamed and
> behold a ladder set up on the earth and the top of it reached to heaven:
> and behold the angels of God ascending and descending on it. (Richard
> Rhodes, *The Making of the Atomic Bomb*, Simon & Schuster, 1986)

Hovering above the ladder was the Lord, who spoke to Jacob, and when he finished, Jacob bolted awake and said, "Surely the Lord is in this place; and I knew it not." And Jacob was afraid and he said, "How dreadful is this place! This is none other but the house of God, and this is the gate of heaven." (Moriarty, *Dreamtime*)

My exhortation? Yes, do it. Walk the Gila. Sleep on a rock. And when the Jacob within you arises, hear him well. Exclaim, as he did, "How dreadful is this place!" Yet realize, as he also did, that "this is none other but the house of God, and this is the gate of heaven."

WHITTLING AWAY AT THE GILA WILDERNESS
Dave Foreman

"A wilderness," Aldo Leopold wrote, "should be big enough to absorb a two-week pack trip without crossing your own tracks." To early forester Leopold, *the* wilderness was the pine forest and sheer canyons of the headwaters of the Gila River in the Mogollon Mountains and Black Range in southwestern New Mexico. As I imagine myself on Holt Mountain looking into the wilderness, ravens quorking and wheeling below, it is easy to believe that I am sitting with Leopold. His words hang and spangle in the air below us like fall leaves of aspen.

In the second decade of the last century, Leopold became enthralled with the freedom of this remote vastness while concerned that it would soon vanish without positive action on the part of its manager, the U.S. Forest Service. With popular articles in the media and through discussions with Forest Service decision-makers, Leopold pushed his argument that because of the sudden availability and popularity of motor cars in the national forest backcountry there soon would be no place left for those so inclined to practice the primitive arts and skills of pioneer travel—primarily horse and mule packing. In 1924, his work bore fruit. Southwest regional forester Frank Pooler administratively designated a Gila Wilderness Area of nearly 1 million acres stretching west to east from Glenwood to Kingston, New Mexico. Similar areas were soon set aside in other U.S. Forest Service regions, all designated as primitive areas.

A fair question to ask now, nearly ninety years after Leopold and Pooler's gift to the future, is how well have later generations of forest rangers, politicians, and the public carried out their responsibility of stewardship? Protecting the Gila Wilderness Area has been a personal passion of mine for the last thirty-six years, with years of careful study of its history before that. In answer to my question, I can say that we have not done a good job. Had it not been for stout-hearted citizen conservationists like Jim Stowe and principled Forest Service employees like Sam Servis at key times, our caring for the Gila Wilderness would have been far, far worse—a travesty, in short.

More than any other single area, the Gila Wilderness epitomizes the never-ending struggle to protect wilderness and fulfills the conservationist's axiom: "A wilderness battle is never won."

The Gila was the first area specifically protected as wilderness by human civilization, but within eight years of its designation the U.S. Forest Service cut the North Star Road through it, north to south, slicing the Black Range to the east from the rest of the roadless country. The Forest Service claimed the road was needed for quicker communication between its ranger stations at Beaverhead and Mimbres and as access for fire-fighting, private livestock management, and hunting. A key reason, however, was that this region of the east fork of the Gila River was dusty, piñon-juniper steppe, and, in the aesthetic eye of the Forest Service, not pretty enough to be wilderness. This scenic bias drove Forest Service policy on the Gila's boundaries for fifty years and still plays a role in undermining efforts to add other lower-elevation lands to the wilderness. Part of the Gila Primitive Area east of the new road was redesignated as the Black Range Primitive Area.

With the road came the extermination of the grizzly and lobo. The North Star Road ripped through high mesa country—gentle land rare in a roadless condition. Ranchers, hunters, and fuelwood cutters in early pickup trucks began to branch off on either side of the North Star Road and push deeper into the Gila Primitive Area to the west and the Black Range Primitive Area to the east during the 1930s, leaving a network of two-track routes. During World War II, several thousand acres believed to have critical minerals were excluded from the primitive area boundary on the south where the Gila River flows out of the mountains. After World War II, army surplus jeeps were brought home and used to further pioneer two-track routes into the primitive areas while the Forest Service shrugged its shoulders.

The heart of the Gila is where the three forks of the river come together. This valley also held hot springs, private inholdings, ranch headquarters, and the Gila Cliff Dwellings National Monument. Every year the Forest Service led a jeep caravan twenty miles through their Gila Primitive Area to the Gila Cliff Dwellings, officially violating its own management standards. This was a big, well-publicized event and attracted a lot of participants. During this time, the Gila National Forest supervisor bet that he could drive his jeep some thirty-five miles farther across the Gila from the Cliff Dwellings northwest over Turkey Feather Pass to Willow Creek. He almost made it. I have a photograph of a crumbling little bulldozer deep in the wilderness that had been specifically designed to maintain primary wilderness trails.

During the 1940s and 1950s, the Forest Service undertook a program to review all of the primitive areas that had been created during the 1920s and '30s to determine

whether they should remain protected and, if so, to draw firm boundaries for them. After study, the areas were to be called wilderness areas if they were over 100,000 acres and primitive areas if they were under 100,000 acres. In 1952, the Forest Service issued its recommendations for the Gila. Already cut down from its original near-million to 560,000 acres, the Gila National Forest would now be reduced to 300,000 acres by lopping off more than 100,000 acres in the east alongside the North Star Road, where the Forest Service argued the gentle topography made defense against vehicles impossible. Further reductions included eliminating the Gila Cliff Dwellings, the valley around it, and the access route from the south into it. A paved road into the Cliff Dwellings for tourists was planned. In perhaps the most grievous of all, it was proposed that another 100,000 acres of towering old-growth mixed-conifer and ponderosa-pine forest around Iron Creek Mesa in the north be pulled out for industrial logging and roading.

The Forest Service's silver-tongued flimflam justifying the "slight" boundary revisions almost won over the far-away Wilderness Society and Sierra Club. Local hunters, fishers, hikers, and horse-packers knew better. The Veterans of Foreign Wars, the American Legion, gun clubs, women's clubs, gardening clubs, chambers of commerce, and service clubs from southwestern New Mexico didn't just say no. They said, "Hell, no!" and they drew a line in the sand. This brought national groups like the Wilderness Society and Sierra Club around, and New Mexico Senator (and former Secretary of Agriculture) Clinton P. Anderson stepped forward as the conservationists' champion. The Forest Service quickly backtracked and came out with a revised proposal in 1953: a 429,000-acre Gila Wilderness Area (including Iron Creek Mesa) and a 130,000-acre Gila Primitive Area for further study. The locals, including some good boosters, hadn't objected so much to the paved road and exclusion to the Cliff Dwellings, so a twenty-mile-long, one-mile-wide corridor was whittled out between the wilderness and the primitive area.

Alas, the Forest Service took the knife to other primitive areas much as they had to the Gila, and some areas did not have stalwarts such as those in Silver City to head 'em off at the pass. The Forest Service attack on primitive areas and its fevered drive to road and log the backcountry led Howard Zahniser of the Wilderness Society and others to call on Congress to protect wilderness areas with a Wilderness Act. An eight-year battle raged with fierce opposition to the Wilderness Act from the Forest Service and Park Service alongside traditional landscalpers such as the logging, mining, livestock, irrigation, development, oil and gas, and industrial tourism industries.

While the Wilderness Act was being debated, the U.S. Forest Service allowed gasoline-powered windmills to be installed for cattle watering in both the Gila and

Black Range primitive areas up to six miles from the North Star Road. Moreover, from 1958 to 1962 the Forest Service chained several thousand acres of piñon-juniper woodland in the two primitive areas (chaining is done by dragging a ship's anchor chain between two D-9 cats to rip out the vegetation to "improve" cattle pasture).

In 1964, the Wilderness Act became law, and all existing national forest wilderness areas became instant units of the new National Wilderness Preservation System. The act directed the Forest Service to study the remaining primitive areas and give Congress recommendations by 1974 on how much should be designated as wilderness. In 1969, the Forest Service proposed a paltry 188,179-acre Aldo Leopold Wilderness for the 169,356-acre Black Range Primitive Area and some high-elevation additions. The New Mexico Wilderness Study Committee (NMWSC) and other groups, reflecting their high-country recreational bias, countered with a better but, as we shall see, inadequate 231,000-acre wilderness line.

In 1972, the Forest Service combined its study of the Gila Primitive Area with an overall boundary revision of the Gila Wilderness. True to history, it once again proposed omission of most of the gentle mesa country near the North Star Road, just as it had done for the corresponding part of the Black Range Primitive Area in 1969. The Forest Service's new proposal totaled 543,474 acres of wilderness. My first task for the NMWSC was to work with Jim Stowe and the Gila Wilderness Committee to develop "The Joint Conservationists' Gila Wilderness Area Proposal" and organize support for it, including turnout at the public hearings in late 1972. We conservationists proposed 614,000 acres. While Congress dragged its feet during the 1970s, conservationists and the Forest Service increased their recommendations. The enlargements were significant for the conservationists (around 400,000 acres for the Aldo Leopold Wilderness and around 700,000 acres for the Gila Wilderness) and slight for the agency. Throughout this time I was insistent that we look at the Gila and Aldo Leopold together as parts of a single wilderness complex and not as two separate island-like units as the Forest Service did.

In 1980, Senator Pete Domenici and Representative Manuel Lujan Jr. were ready to move on a New Mexico wilderness bill for national forest areas. The main opponent to wilderness in southern New Mexico, Democratic Representative Harold Runnels, had passed away, and the seat was temporarily vacant. We saw it as a window of opportunity. Our other senator at the time, Harrison Schmitt, a geologist and moonwalking astronaut from Silver City, was no friend of wilderness and kept acreages small but would at least go for some wilderness. Although I had left employment with the Wilderness Society by that time, I took the bus back to Washington as a citizen representative of the Wilderness Study Committee to coordinate the back-

and-forth between the House and Senate at the end of the session. I made clear to my friends Domenici and Lujan that we had to bring the wilderness boundaries for the Gila and Aldo Leopold down to half a mile of the North Star Road. Otherwise, we would ask to kill the entire bill. We ended up with a 570,000-acre Gila Wilderness Area and a 211,300-acre Aldo Leopold Wilderness Area—pretty small potatoes in some ways, as were other wilderness boundaries elsewhere in the state. The significant victory was that the two wilderness boundaries were each brought down to one-half mile from the North Star Road, leaving only one mile between them. Had the Forest Service boundaries prevailed in 1980, the nonwilderness gap would have been up to ten miles. Knowing what we now know about the importance of connectivity for wildlife movement between protected areas, this was a real victory.

Most of the other lands conservationists proposed for addition to the Aldo Leopold and Gila in 1980 still qualify and are even more important now for biodiversity. The two largest undesignated national forest roadless areas in New Mexico are the 190,000-some acres around the Aldo Leopold Wilderness and the 130,000-some acres around the Gila Wilderness. As political conditions change, New Mexico conservationists must be alert for any opportunities to enlarge the big wilderness complex of the Gila National Forest.

Maybe by the time of the 100th anniversary of the 1924 designation of the Gila Wilderness we will have finally added enough land to the Gila and Aldo Leopold so that in connection to surrounding wildlands they are large enough to once again play as "the theater of evolution," as Leopold wrote in 1937.

DREAMING THE RIVER

M. H. Salmon

Many have found the Gila River an inspiration, something from a time gone by, the stuff of dreams—an improbable, virtually pristine run of water cleaving the desert and worthy of a fight to keep it in free flow. In time, I would come to view the river in such a way myself. But my initial view of the fight could not have been more mundane. And my first contact with the river left me underwhelmed.

New to the area, circa 1980, I was in a tire shop in Silver City one morning, troubled by a chronic slow leak. I waited in the lobby while a man in coveralls removed the tire, searched for the nail, eventually found it, and patched the leak. It was time enough for me to notice a news article tacked to a bulletin board in the shop. It was old, yellowed, and dated to the 1960s, but the gist of it was that the New Mexico Interstate Stream Commission was down in Phoenix negotiating with the Bureau of Reclamation and the state of Arizona to capture 18,000 acre feet of the Gila River per year for consumptive use in New Mexico.

"In the planning stages since the 1920s, the Hooker site has already been chosen for the dam," the article said to the best of my recollection, accompanied by a simple map indicating the location of the dam and a reservoir depicted as a clear blue lake backed up some twenty miles behind the dam. A newcomer, I nonetheless knew that the Hooker Dam had never been built, and I wondered what had happened in the intervening years to thwart the plans.

While I sat waiting at the shop, an earnest fellow, rife with the cause, came in seeking signatures on a petition favoring—coincidentally—a dam on the Gila River in New Mexico! Local business was behind the project, he said. This tire shop was a hangout for local business and the sort of man who, like me, sported work boots and a tractor cap, and many there were happy to sign. But others, I noticed, declined, and one ol' boy gave the petitioner such an icy glare he hastily gathered his papers and exited without ever getting to me. Being a newcomer, I was just as glad I hadn't had to takes sides, but I was eager to see what all the fuss was about. I paid the man

in coveralls $5 for the tire repair and made plans to learn what I could about this Gila River.

The Gila, at 3.3 million acres, is the largest national forest in the lower forty-eight. It is a unique biome where the Rocky Mountains meet the Sierra Madre. It's also hosted a dramatic human procession ranging from the artistic Indios Mimbres to Geronimo and Mangas Coloradas of the incorrigible Apacheria. Western notables like the outlaw Butch Cassidy and mountain men James Ohio Pattie and Ben Lilly also figure into the story. Aldo Leopold established the Gila as the nation's first wilderness designation in 1924. Its lifeblood is the Gila watershed, the last undammed river in New Mexico. I had to see it for myself.

I first visited the Gila on a Sunday morning, a mistake. The campground was awash in humanity, far too many in possession of some sort of all-terrain vehicle. They roared about, raising dust into the lofty, shading sycamores, willows, and cottonwoods, ancient giants that could recall quieter times. And, if any difference could be measured, the river looked even sadder than the trees, a meager flow at best. Big tires crossed its riffles at will, teens played grab-ass in its pools, and cows had stripped its banks of the nurturing greenery that held the river to form in time of flood. I parked my pickup, took a chew of Red Man, grabbed my daypack and fishing pole, and headed upstream in search of less-molested waters.

In little over an hour I entered another world. The last vehicle was now behind me, though I could faintly hear its distant boom box. The canyon walls had come in especially close, right where the river made a turn and formed a sizeable pool. It was the same meager flow, but here were blue-green waters where you couldn't see the bottom. Fish, some of a size to interest a fisherman, were green and bronze shadows moving in the depth. Not far away a Mexican black hawk and a great blue heron were angling, one from the air where he could show off extra-broad wings, the other standing on stilts in the shallows, a patient spearman. For the remainder of the day, I had this bend in the river to myself. I watched bighorn sheep come for a drink, confidently picking their way down a cliff that I wouldn't have attempted with ropes and pinions. I ate lunch; took a nap; caught green and bronze smallmouth bass, some of them over a foot long; and determined from my maps that I was at play at the proposed Hooker Dam site.

I felt ecstatic, in a way perhaps only another fisherman would understand: I had caught smallmouth bass—the gamest fish that swims—born and raised in the last free-flowing river in New Mexico. I thought, next time I'll catch them on flies. For this angler, it was altogether transcendent. By the time I returned to the truck, it was dark, the campground virtually empty. I suppered on my last remaining fish and qui-

etly resolved for a second chance to accost that lackey with the petitions in the tire shop. I wasn't on the fence anymore.

Throughout the 1970s the battle raged over building the Hooker Dam. Nobody not guilty of a felony should have to attend that many agency meetings, public hearings, and private strategy sessions without pay. The newspaper article I'd seen had been correct about the authorization and funding coming from the Central Arizona Project of 1968. In return for the support of this $4 billion water hydra, the New Mexico delegation, led by Senator Clinton Anderson, extorted from Arizona the New Mexico Unit of the CAP, 18,000 acre feet per year from the Gila in New Mexico, provided certain environmental and economic parameters were met. The money was there in the form of a sub-prime government loan. And the Hooker site, about a dozen miles upstream from the town of Cliff, had indeed been the first choice. As momentum grew it looked increasingly like a "go" for Hooker Dam. Boosters touted jobs and growth, flood control, lake rather than stream recreation, and that age-old paradigm of western states water management known as "beneficial use," that is, a water right is only valid if it is diverted and consumed. Above all, the boomers said: "Keep our water from running down into Arizona!"

But the Gila had defenders, too; they voiced alarm at the specter of an artificial lake backed up a dozen miles into the Gila Wilderness and spoke up for several rare species that would be impacted by the dam project. And, upon further review, the engineers voiced concern that the geology of the Hooker site was suspect as a foundation for a big holding dam. Consequently, early in the 1980s the proposed site was moved twenty miles downstream to the Middle Box Canyon and the Conner Dam site, and, later, the Mangas Diversion.

Again, momentum grew for the project. New Mexico State engineer Steve Reynolds skillfully played the "beneficial use" card. But now there was a new beneficial use in the public mind, if not yet recognized in state law—instream flows. Water left in the stream offers benefits, promoting fish, wildlife, and recreation, which, in turn, yield a positive economic as well as aesthetic result to the human community. When, at a public hearing, the dream-loving river people outnumbered the pro-dam people in the town that was supposed to benefit from the project, Silver City, the Bureau of Reclamation began to rethink a dam on the Gila in New Mexico. When the prodigious groundwater reserves of the Mimbres Basin (some 70 million acre feet, according to Steve Reynolds himself) were finally made public, plain folks and agency personnel alike began to question whether the goal to "keep the water away from Arizona" was sufficient rationale to whack the heart out of a free-flowing stream. Both the Conner Dam and the Mangas Diversion were shelved.

Enter the Arizona Water Settlements Act (AWSA) of 2004. Intended to settle Native American water rights claims in the greater Phoenix area, and commonly referred to as "pork wrapped in an Indian blanket," the $2 billion deal included up to $128 million for a "New Mexico Unit." Once again New Mexico's congressional delegation had traded support for a big Arizona project for a smaller one in New Mexico. The AWSA is complex, but suffice it to say it would involve a diversion to off-stream storage, much like the Mangas Diversion; the take would be down from 18,000 acre feet per year to 14,000; and the proposal would have to clear the same hurdles as the previous project: threatened and endangered species, public opposition, and the presence of cheaper groundwater resources in the same region. Nobody seems willing or able to contract for the water which will exceed the subsidy by $100 million, maybe $200 million. As of spring 2011, the Gila River in New Mexico is still a wild river, and the same people, or their philosophical kinfolk, can't stand it and are pushing for a diversion, ironically not far from the old Hooker site.

In *Sky Determines,* Ross Calvin wrote: "Here if anywhere is air, sky, earth fit to constitute a gracious homeland, not alone for those who occupy themselves at the world's work, but as well for those who study and create, for those who play, for those who sit still to brood and dream." Michael Berman and I share a kinship. He, the photographer, has taken on the loftier goal to study and create. I, the fisherman, come mostly to play. But we are both, like so many others, dreaming the river.

THE EPHEMERAL WITHIN THE ENDURING

Mary Katherine Ray

There is an old grizzled oak tree in the canyon where I live, just outside the boundary that officially marks the Gila. Without a map, though, the dividing line is not apparent. The tree is on national forest land, and among all the other oaks, piñons, and junipers, it is easy to overlook. The Forest Service doesn't know of its existence. I know of it because it's within walking distance of home and is a good place to turn around. It isn't very tall by most tree standards, but at the base the massive trunk is the size of our dining room table. The branches are twisted and gnarled, and in several places they are dotted with hollow holes that provide shelter for birds, squirrels, mice, and bees under the gray furrowed bark.

Compared to this old oak tree we haven't lived in the canyon very long—only a couple of decades. This tree began as a seedling easily several centuries ago. The Apaches would have been the people here then. It's a harsh place on which to have to rely for food to survive without being able to bring in groceries from somewhere else. I close my eyes and try to picture what it might have looked like then. The canyon would have had the same contours it has now, the hills lining each side perhaps less eroded, but the view downhill across the Alamosa floodplain to the Black Range that describes our western horizon would have been unchanged. There would have been junipers, piñons, and oaks along with shrubs like Apache plume and three-leaf sumac, and the grasses would have been here, too: blue grama, sideoats, and dropseed, along with the annual love grasses and three awns. But the proportions would surely have been different. The stream that made this canyon now only has water during floods and is dry most of the year. Only a few remnant narrowleaf cottonwoods remain this far down, and they are in decline. They don't put up new shoots,

and it isn't wet enough for them to start from seed. Most are playing nurse trees, not to seedling cottonwoods but to young junipers. Times have changed. This place has been made harsher by the advent of European settlement and with it the commodification of the land for livestock, logging, and mining.

There is an informational roadway sign on the way here with a tribute to the Warm Springs Apaches. It tells about the Ojo Caliente, the spring that was sacred to them, and the surrounding area where they spent their summers. It was all set aside for their people, but after many betrayals and a violent insurgency that took years to subdue and that resulted in Chief Victorio's death the promise of the land was not kept and the few remaining Warm Springs Apaches were shipped to Florida as prisoners of war.

I shudder to think of living in a flat place with no mountains defining the horizon and humidity so heavy it is hard to breathe. But live there the Warm Springs Apaches did for more than twenty years. In 1912, they were finally released from captivity, but when they returned to their sacred Warm Springs they found the land "ruined" by homesteaders and they gave it up, choosing instead to meld into other Apache bands. The informational sign is riddled with bullet holes.

Despite the changes in vegetation, the Warm Springs still gush out of a dry arroyo, making such a stark contrast that anyone can tell it's a miracle and should be deemed sacred. In the steep-walled Cañada Alamosa, the water still runs faithfully all year, just as the Apaches knew it, and with care from the farmers who use it downstream the cottonwoods and willows are returning. It is a testament to the resiliency that water confers and to the tragedy of what has been lost in so many other canyons.

In 1919, Aldo Leopold, the great conservationist who learned much from what he saw in the Gila region, described a turkey hunt he went on just two canyons to the north of here. Going afield with the intent to kill holds no attraction for me, but I hang on every word about his outing while looking at the map, trying to trace his footsteps across the grassy hills and wooded draws. My footsteps have fallen in the same places. Leopold describes seeing white-tailed deer on his quest, but there are no whitetails now. There are still a few mule deer, which Leopold called "black-tails." What there are now, and what were completely absent in 1919, are elk. These are the Rocky Mountain elk that were relocated from Yellowstone in the 1960s to replace the vanished Merriam's elk, which had been extirpated by overhunting in the nineteenth century. Leopold might have heard the howls of wolves on his turkey hunt, even though he didn't write about it. But the Mexican wolves were finally also extirpated, unable to withstand the arsenal of traps and poisons used against them. Grizzly

bears were all but gone by 1920. Our rancher neighbor told me where the last one was shot in these mountains. My footsteps have fallen there, too.

In this area, before European settlement, before the Apaches, there were the pre-Columbian people who built the pit houses that are on the benches just above the canyon bottoms. There are ruins on the canyon banks above the old oak tree. If you weren't looking carefully, you might not even notice that the piles of rocks are not a natural feature. But kick around in the dirt between the grass clumps and you will likely turn up an arrowhead flake or ceramic fragment. It might be a piece of simple textured brown coil pottery or a beautiful black-on-white piece with angular and hatched designs, the whole picture tantalizingly elusive because too much is missing. I never cease to shiver with the realization that one thousand years could have passed since a human hand last touched such a shard. For these people with permanent settlements, permanent water could not have been over four hundred feet below ground as it is now. I try to visualize the plentiful water supply that supported these communities not only with drinking water but also for crop irrigation. I take heed that the pit house builders who lived here for generations had disappeared by the time the Apaches arrived.

A thousand years from now, I wonder what will be left of our house; its roof long collapsed and the walls caved in. What objects that I hold now might one day be kicked up in pieces from the dirt by someone else? How different will the canyon look?

The old oak tree has seen some travail of late. A windy spring a couple of seasons ago broke off nearly two thirds of it. Those big branches are slowly decaying on the ground nearby. There was a drought year that outright killed lesser trees. But the old oak lives on, and even in old age last year's wet winter brought on a bumper crop of new acorns. They fell to earth late this summer at the foot of its enormous base to be gathered up in jays' caches and in rodent burrows. But some were overlooked, and maybe one will sprout so that a thousand years from now there will be a different old oak tree in this spot, because even oak trees don't live forever. Perhaps some other traveler will then stand near its gigantic trunk in awe of its age and take in the view of the familiar mountain vista of the Gila and wonder.

EQUILIBRIUM

John C. Horning

There is a place deep in the heart of the Gila Wilderness called Serenity Canyon where ochre-barked ponderosa pine giants extend upward to meet the basalt rim of the volcanic plateau known as McKenna Park.

One late fall morning, my companions and I sat in silence where a fallen giant now bridged the canyon walls. The autumn sun warmed us as we gazed upon the oak leaves that covered the canyon floor with their crinkled palms turned upward as though waiting, praying for rain.

Although you won't find it on a map of the Gila, Serenity Canyon does exist. It is one of a handful of canyons that drain McKenna Park, where the Southwest's last ponderosa pine giants still stand, thanks in large part both to the wisdom of Aldo Leopold and to the frequent and necessary blessings of fire.

Fire has been a vital part of the ecological equilibrium of these forests and savannahs for eons. But that knowledge didn't put me any more at ease when, a few years earlier, another companion and I came upon a wild fire as it danced across the grassy carpet of another of the Gila's ancient ponderosa pine forests. We walked for nearly two days through a mosaic of flame, smoke, and grass—an experience that still enlivens and informs me nearly ten years later.

I have had many ecological epiphanies in more than two decades spent walking, biking, floating, and driving throughout the protected and unprotected wildlands of the Greater Gila, but that encounter with fire—more than any other experience—has deepened my connection to and understanding of what makes the Gila unique.

This is a land whose pulse can still beat wildly.

It is a place where fire and flood endure, where lobos survive and beaver thrive, and where wild rivers still run free; where the cauldron of evolution—thanks to the natural confluence of the Sonoran, Chihuahuan, Sierra Madrean, and Rocky Mountain ecosystems—bubbles to create a rich tapestry of life; and where we Americans first chose, with Leopold as the catalyst, restraint over exploitation.

Although there is much to celebrate about the Gila, each effort to protect its soils, waters, and wildlife has been a struggle, and today there is still much to secure.

The first time I came to the Gila and Apache National Forests, in the winter of 1990, many of the region's precious streams had been denuded by year-round cattle grazing, the lineage of the last few lobos were still stuck in zoos, and the U.S. Forest Service was just beginning to question the wisdom of a century of fire suppression.

The last time I was in the Gila, in the fall of 2010, I was reminded of how much work still needs to be done to live up to Leopold's visionary land ethic and his wilderness ideal in the place that first inspired both.

On the final night of our week-long trip, I was awakened by the haunting howls of lobos. I later learned that these were not just any wolves but rather the defiant three-legged lobos of the Middle Fork pack, each of whom has had a front leg amputated, one as the result of a steel leg-hold trap, the other from a reckless human with a shotgun.

If the lobo—and fire—are to endure in a landscape that is their ancient birthright, then it's clear to me that we will need to continually exercise restraint and be vigilant in advancing an ethic of stewardship that celebrates all the Greater Gila has to offer.

But how much is enough? Adding an additional 2.2 million acres of eligible wilderness to the wilderness areas that already protect the Blue and Black Ranges and the Mogollon Rim? Securing a free-flowing Gila River in perpetuity? Protecting a population of four or five hundred or more lobos?

I can't say that I know exactly.

What I do know is that the most lasting lesson of my days and nights on the crest of the Mogollon Rim or along the three forks of the Gila River is that ecological dynamism—not lines drawn on the map to designate a park, or a monument, or even a wilderness area—is the holy grail that I seek to sustain. And that sustains me in return.

A COMMUNION WITH SKY

Philip Connors

New Mexico's Gila National Forest is among the most fire-prone places in America. From a lookout tower on its southern edge, I have a view over a stretch of country where an annual upsurge of moisture from the Gulf of Mexico combines with the summertime heat of the Chihuahuan Desert to create massive cumulous convection and wicked lightning shows. In an arid land with brief but intense storm activity, wildfire is no aberration. It is the forge in which the ecosystem was shaped.

Although tens if not hundreds of thousands of acres are touched by fire here every year, I can go weeks without seeing a twist of smoke. During these lulls, I simply watch and wait, my eyes becoming ever more intimate with an ecological transition zone encompassing dry grasslands, piñon-juniper foothills, ponderosa parkland, and spruce-fir high country. On clear days I can see mountains in three states and two countries—the Franklins in far west Texas, the Pinaleños in eastern Arizona, and the northern reaches of the Sierra Madre Occidental in Mexico. To the east stretches the valley of the Rio Grande, cradled by the desert: austere, forbidding, dotted with creosote bushes and home to a collection of horned and thorned species evolved to live in a land of scarce water. To the north and south, along the Black Range, a line of peaks rises and falls in timbered waves. To the west, the Rio Mimbres meanders out of the mountains, beyond which rise more mountains—the Diablos, the Jerkies, the Mogollons—a rugged jumble of ridges and canyons that comprise the heart of the Gila Wilderness.

Having spent a thousand days in my little glass-walled perch over the last decade, I've become acquainted with the look and feel of the country each week of

each month, from April through August: the brutal gales of spring, when a roar off the desert gusts above seventy miles an hour and the occasional snow squall turns my peak white; the dawning of summer in late May, when the wind abates and the aphids hatch and ladybugs emerge in great clouds from their hibernation; the fires of June, when dry lightning connects with the hills and mesas, sparking smokes that fill the air with the sweet smell of burning pine; the tremendous storms of July, when my radio antenna sizzles like bacon on a griddle and the lightning makes me flinch as if from the threat of a punch; and the blessed indolence of August, when the meadows bloom with wildflowers and the creeks run again, the rains having turned my world a dozen different shades of green. I've seen fires burn so hot they made their own weather; I've watched deer and elk frolic in the meadow below me and pine trees explode in a blue ball of smoke. If there's a better job anywhere on the planet, I'd like to know what it is.

My office is a 7 by 7 foot box on stilts. Twenty paces from the cabin, sixty-five more up the steps of the tower, and just like that I'm on the job. Each April, after splitting a good stack of firewood, cleaning up the mess left by overwintering rats and mice, and putting up the supplies packed in by mule, I begin more or less full-time service in the sky, 9:00 a.m. to 6:00 p.m., with an hour off for lunch. My scheduled work hours are similar to those of any other jogger on the hamster wheel of the eight-hour day—except that my job involves an exquisite intimacy with wilderness, and I ply my trade inside a steel-and-glass room immaculately designed to attract lightning. It's no wonder I and my kind have been referred to as "freaks on the peaks."

For most people I know, this little room would be a prison cell or a catafalque. My movements, admittedly, are limited. I can lie on the cot, sit on the stool, or pace five paces before I must turn on my heel and retrace my steps. I can study once again the contours of the mountains, the sensuous shapes of the mesas' edges, the intricate drainages fingering out of the hills. On windy days in spring, I turn my gaze upon the desert, a feast for the eye if you like your country spare. In early afternoon, I follow the formation of dust devils through my field glasses. Their manic life and sudden death seem to me a fruitful field of inquiry when the mind bogs down in solipsism. Far off on the desert floor, where once a great inland sea bubbled, the earth writhes up in the shape of a funnel. Scorched by sun and scoured by wind, the ancient seabed surrenders itself to points east, eventually to be washed to the Gulf in the current of the Rio Grande.

In quiet moments I devote my attention to the local bird life. I listen for the call of the hermit thrush, one of the most gorgeous sounds in all of nature, a mellifluous warble beginning on a long, clear note. Dark-eyed juncos hop along the ground,

searching for seeds among the grass and pine litter. With no one calling on the radio, I swim languidly in the waters of solitude, unwilling to rouse myself to anything but the most basic labors: brush teeth; piss in meadow; boil water for coffee; observe clouds; note greening of Gambel oak. The goal, if I can be said to have one: to attain that state where I'm nothing but an eyeball in tune with cloud and light, a being of pure sensation. The cumulus build, the light shifts, and in an hour—or is it two?—I'm looking at country made new.

Between five and fifteen times a year I'm the first to see smoke, and once I've called it in, my superiors must choose a response. For most of the twentieth century, the reaction was preordained: full suppression. A military mindset prevailed in the early Forest Service, and the results for America's public lands proved disastrous. Attacking every fire the moment it was spotted warped ecosystems that had burned on a regular basis for millennia. Retreating urbanites became convinced they could build their dream homes amid the forests with impunity. Smokejumpers would float out of the sky and save the day if the call came. The fact remains that wildfire has a mind of its own, as we've learned the hard way. The lessons will only get harder in a warming world, but here in the Gila officials are committed to making fire a part of the life of the forest again. They let certain lightning-caused fires burn for weeks at a time, over tens of thousands of acres, making the Gila healthier than it would be otherwise: more diverse in the mosaic of its flora, more open in its ponderosa savannah, with less of the brushy ladder fuels that now make the American West an almost annual show of extreme fire behavior. With crews on the ground monitoring big blazes, I keep track of crew movements and wind shifts, offer updates on fire behavior and smoke drift. I watch their weather when they sleep outside. I let them know when lightning is coming. I'm their eyes in the sky.

It probably goes without saying that lookouts are not a growth industry. There were once thousands of towers scattered across America, but only a few hundred are still staffed each summer. Some in the Forest Service have predicted our impending obsolescence, thanks to better radio technology, more precise satellite imagery, perhaps even unmanned drones taking pictures on low-level flyovers. If there's one axiom of the world we've devised for ourselves, it's that a new technology will always be found to replace the inefficient human hand. But in a place like the Gila—where so much of the country is rugged and remote, off-limits to motorized equipment and new roads—lookouts are still the only communication link to the outside world for certain backcountry crews, at least for the time being. At around thirteen bucks an hour, we also remain far cheaper than aerial surveillance. Safety and fiscal prudence— these will be the saving graces of the lookouts who manage to hang on.

Aldo Leopold, who drafted the proposal to preserve the Gila Wilderness in 1922—a plan that made the headwaters of the Gila River the first place on earth to be consciously protected from industrial machines—once wrote: "I am glad I shall never be young without wild country to be young in. Of what avail are forty freedoms without a blank spot on the map?" Survey the lower forty-eight on a coast-to-coast flight, and the most interesting country never fails to be that without roads. Down there amid one of those fragments of our natural heritage is a forest that burns and a desert that dances, twenty thousand square miles of harsh and beautiful country visible from a tower nearly two miles above sea level. The view some days overwhelms me with its vastness, so I turn back to the earth beneath my feet. Wild candytuft bloom under the pine and fir, followed later in the season by wallflowers, paintbrush, mountain wood sorrel, Mexican silene. On my evening rambles I find Steller's jay and wild turkey feathers, snake skins and mule-deer bones. Now and then an hour of hunting turns up a relic in the dirt, not far from the base of my tower: a turquoise bead or a Mogollon potsherd, white with black pattern, well more than eight hundred years old. I am given to understand the people who once gathered in the high places and brought with them their crockery. They sacrificed their pots by smashing them to earth in hopes the sky gods would grant rain. Clearly I am not alone in my communion here with sky. Far from it. The ravens and the vultures have me beat by two hundred feet, the Mogollons by most of a millennium. And who's to say the dust motes off the desert don't feel joy, if only for a moment, as they climb up into the sky and ride the transport winds?

THE GILA WAPITI AND ME

Alex G. Muñoz Jr.

Gazing into the campfire, memories of past encounters of near misses and successful elk hunts race through my mind as if they were yesterday.

It is a cold September night; I hunker down closer to the fire, seeking its warm and calming heat. My hunting partners have all retired in anticipation of the morning elk hunt. For me, it is quality time. Not much for words and casual conversation, and very much a loner, I have always been content just having my thoughts, being out-doors, and, on occasion, having a soul-searching conversation with myself. Looking up to the sky, a million stars greet me; hello, my familiar friends, it's been a long time …too long. A burst of wind sends a shiver down the back of my neck; looking down at the fire, I see it has dwindled to embers, and the cold has become unbearable. I am so tired I can't keep my eyes open—time to call it a night.

With coffee in hand, my mind struggles to put things together; soon my third cup kicks in. In no time at all I am dressed. My day pack is ready. I pull my bow back several times, loosening my muscles. But something is wrong; the feeling grows stron-ger. I've forgotten something. An inventory of gear, food, water, that's not it; I can't put my finger on it. Rustling through my vest, I feel my camo-pac—that's it, face paint. I open the makeup pack and apply my face paint. Soon I am invisible.

Looking at the mountain horizon, I see the light is beginning to break; time to go. My three hunting partners and I exchange a ritual farewell of good luck and be safe. We turn our separate ways, melting into the darkness.

Reaching a familiar mountain ridge covered with aspens and tall ferns, I check my equipment and take a water break. The forest is beginning to come alive. I put

a cow elk diaphragm in my mouth, adjust my elk bugle, and ready my bow. I begin a series of six to seven cow meows. Minutes go by. A faint bugle sounds on a distant ridge top, then another; I answer with softer enticing cow calls; the bull answers back. I try a few more calls, with no response. I ease up my elk bugle and let out a locater bugle. Before I finish, the bull responds from a couple of hundred yards below me. A few soft cow meows do the trick. He is all worked up and closing the gap. Fifty yards ahead is a grassy bench with small pine trees. I make my way there, move into position, and knock an arrow. I pull my bow back and check my shooting lanes; perfect—twenty, maybe twenty-five yards. Down on one knee, I wait. My heart is racing. I can hear my heart pounding. I am running out of time. I call again; silence. I wait and wait; complete silence. Convinced the bull is gone, I get ready to leave. I let out a few more cow calls. A thunderous growling bugle erupts from behind me. Quickly I turn around to face the bull. With one swift move I raise the bow and ease the string back, anchored and ready. I let out a faint enticing cow meow. The bull roars back, followed with a few growling raspy chuckles. He is just below me. I hear rocks rolling down as he is making his way. Suddenly, white ivory antler tips appear, followed by the rest of his rack. Now his head, chest, and front legs appear. He is standing twelve yards in front of me with no vital areas exposed for me to position my shot. It is a waiting game now. Come on, turn broadside. He bugles, followed by a few chuckles. My nerves of steel are seconds away from melting. The gigantic seven-by-eight bull elk is so close I can almost reach out and touch him. Our eyes meet, but he sees straight through me. I am invisible. His nose is dripping and his mouth frothed up. I whisper to myself, "He is ready for a fight." Taking two steps back, the bull's antlers fade away as he goes back down the mountain.

Arriving late to camp, the fire is burning. After supper we gather around the campfire and exchange the events of the day. Soon my friends retire for the night. Over and over I relive the earlier events with these conclusions: I did nothing wrong, the bull did everything right. Glaring into the flames, a calm, soft easiness settles through my body. The warmth lulls me to sleep. Soon a soft cow meow breaks the night's silence and wakes me, then another cow and another. Then a bull starts bugling. Another bull joins in, then another. The meadow below our camp is a chorus of elk sounds. My thirty years of elk hunting in this country tell me it is official—the elk rut is in full swing here in the Gila, and the action is just going to get better.

After two more days, with everyone having close encounters but no luck, I once again put on face paint to make myself invisible and prepare for the hunt. I will need some extra help today. My bones ache and my legs feel like lead. My shoulders are purple from my heavy pack. A couple of ibuprofen chased down with some cof-

fee should bring relief. Today a change of plan: I will hunt in a grassy meadow surrounded by deadfall and tall ferns. Knowing elk are always passing through this area, I waste no time getting there. Twenty minutes go by. I let out a hard, raspy locator bugle, followed by another with a series of raspy chuckles. To my right, a bull answers. He is several hundred yards away. I answer him, intensifying the bugle. He bugles back. Soon a second bull, to my left, joins in the chorus. Quickly I move forward and position myself between the two bulls. I bugle again. Both answer simultaneously; both are now worked up and ready for a battle. I let them talk to each other, moving closer and closer; I'm in the middle. I begin to hear cows meowing. They are with the bull to the right and just above. The cows become visible and are vigorously meowing at the bull behind me. Out of the corner of my eye, I see movement. The lone bull charges out about fifty yards in front of me and starts tearing up a blue spruce. In seconds the tree is completely demolished. He gathers up a single cow and starts to move away. The rest of the cows begin to follow but are cut off by the herd bull passing only thirty yards in front of me. The bull's huge antlers are long, wide, and down past his flanks as he disappears behind the cows, pushing them away. I bugle a raspy challenge, over and over.

Suddenly I see the bull's huge antlers come out of the trees. Head held high and stiff, he is roaring a terrifying bugle. He is mad and has come back for his cow. A couple of cow calls do the job. He lowers his head and beelines my way. Quickly I knock an arrow and draw; he stops to rake a tree thirty yards in front of me. I cannot get a shot. He begins to move off, and I bugle again and again. He stops dead in his tracks and swirls his huge massive rack around. He is headed my way. I draw again as the bull closes the distance. Forty, thirty—he is going left now—twenty yards. I let out a soft meow. The bull stops broadside and looks my way. Quickly I find the spot and release; the arrow disappears behind the bull's shoulder. The majestic bull vanishes into the ferns. An eternity passes. I wait to give the bull some time and collect myself; I know it was a well-placed shot. I follow the telltail trail the broad head has left me. A short distance away I see white-tipped antlers followed by the massive six-by-six rack. The bull is down. As I kneel beside him, I bow my head and pay my respects to the magnificent majestic bull. It is late and I must hurry. I quarter the bull and hang the meat. I secure the huge rack and all the meat I can carry on my pack. We will pack the rest of the meat out in the morning.

It is dark now, but I know the general direction to camp. I look up to the sky and say: "Take me home my friends." Working my way down the ridge, I see a familiar glistening fire. Just as I break the tree line, I see my two friends standing by the fire; the roaring glow now reveals the rack on my back. My friends help me off with the

load. Over and over, I recount the events. Soon my friends retire. It will be a long day packing meat out tomorrow.

I curl up in a ball, laying my head down. Through the diminishing flames I see the antlers on the other side of the fire ring. My journey has come full circle here in the Gila. I was blessed to see a black bear sow and her two cubs. A red-headed gobbler snuck up behind me and gobbled while I was cow calling, nearly giving me a heart attack. I crossed a few ice-chilled streams, which got my blood going. The chattering squirrels gave up my position many times, sending the elk running the other way. The midday lunches among the golden aspens and fern-covered ridges were humbling. It is beautiful country here—rugged, ruthless, and breathtaking.

GOING BACK TO THE LAND IN THE AGE OF ENTITLEMENT

Guy R. McPherson

Working at a major research university required me to live in a city, the very apex of empire. For years, I avoided the nagging voice in my head as it pointed out the horrific costs of imperial living: destruction of the living planet, obedience at home, and oppression abroad. Eventually, though, I could no longer ignore the powerful words of Arundhati Roy in her insightful 2001 book *Power Politics:* "The trouble is that once you see it, you can't unsee it. And once you've seen it, keeping quiet, saying nothing becomes as political an act as speaking out. There's no innocence. Either way, you're accountable." Roy's view is supported well by the philosophy of Camus, which reminds us about the absurdity of our existence and about the struggle to find worth in an act of rebellion. Rebellion cannot be meaningfully pursued while one is shackled to an imperial institution.

I left the easy life of the academy for many reasons, among them to dedicate more time to informing the world's citizens about the consequences of the way we live. My message centers on the twin sides of the fossil-fuel coin: global climate change and reduced energy availability (commonly known as "peak oil"). After all, the most important race in the history of humanity is under way, although the world's governments and the mainstream media have failed to give notice. The world's climate is changing at an accelerating rate, with profound implications for nature and the humans, who depend on the natural world. In addition, the world's energy supply is rapidly declining, which is leading to significant contraction of the world's industrial economy. These unprecedented phenomena impact every aspect of life on earth,

notably including our ability to protect the living planet on which we depend for our own survival. Time is not on our side.

If we continue with business as usual, we likely are committed to a 6° C (roughly 11° F) rise in average global temperature by mid-century. Such a profound and rapid rise in global temperature will reduce, to near zero, human habitat on earth. A reduction in greenhouse-gas emissions by at least 80 percent represents the single remaining hope to save the living planet on which we depend. Such a reduction in emissions of greenhouse gases will necessitate either a near-term trip to the postindustrial Stone Age or a rapid accounting for the actual costs associated with consuming fossil fuels. The latter will require immediate recognition of the explicit links between environmental protection, social justice, and the human economy and therefore an unprecedented transition to biophysical economics. Either way, we're nearing the end of the Age of Entitlement and drawing inexorably closer to the Age of Consequences.

Dealing with the two sides of the fossil-fuel coin—global climate change and reduced energy availability—will require enormous courage, compassion, and creativity. In addition to inspiration and motivation, we need practical local solutions to mitigate for climate change and energy decline (it is too late for societal-level solutions to either predicament). Local solutions must be based on a realistic set of assumptions about climate and energy, and my message centers on the moral, philosophical, and pragmatic aspects of climate change and reduced energy availability.

My message is deeply rooted in the sciences of global climate change and petroleum geology as well as the dismal science of macroeconomics. To me, science is a way of knowing, and perhaps even understanding, the universe we occupy. It differs from other ways of knowing, including through religions, in its transparency and inclusiveness. I am not naïve enough to believe that more than a small minority of Americans will rely on scientific principles or knowledge as a foundation for daily conduct of their own lives, but reliance on rationalism still offers me personal comfort. Contrary to religion, science expands my world.

A few years before I left the academy I completed a sabbatical leave in a small research center owned and managed by The Nature Conservancy (TNC). My time as scientist-in-residence at the Lichty Ecological Research Center introduced me to the dynamic beauty of New Mexico's upper Gila Valley and its human community, as well as to a quirky, adobe house that relied on passive solar for heat. The house had been built in the mid-1970s in response to America's initial energy crisis. While living in the adobe house, I visited now and then with a married pair of naturalists who led tours from TNC's Bear Mountain Lodge to the Lichty Center, where I spent my time thinking and writing. I fondly recall an exchange in which the naturalists' one-year-

old son was resting on his father's shoulders and treating a cattail as his personal magic wand. The seeds of the cattail quickly filled the hair and beard of the forty-year-old naturalist before the boy succumbed to his own personal energy crisis and, fighting all the way down, collapsed into slumber.

One of my sabbatical projects included a book about the dire nature of our predicaments, and I mentioned the high likelihood of a global economic collapse within a decade or so. The naturalist didn't bat an eye before responding: "I hope I'm around to see it. I don't want my son to have all the fun."

At the height of a productive career characterized by frequent awards for teaching and research, my moral compass drove me away from the relative ease of a highly paid job in exchange for the joy of stewarding life in a small community. More than two decades after I started down the academic path that led to a productive career in the ivory tower—and much to the amazement and criticism of my colleagues, many of whom believed my insanity was induced by a rare disease—I returned to my rural roots to live in an off-grid, straw-bale house where I practice my lifelong interest in durable living via organic gardening, raising small animals for eggs and milk, and working with members of my rural community.

I conduct these life-affirming activities less than a mile from the Lichty Center, on property used jointly with the former naturalists of The Nature Conservancy. Fast forward six years from the cattail-covered discussion with the naturalist and I'm sharing property with him, his wife, and their young son. Collapse of the industrial economy is well underway and has entered the acceleration phase of its death spiral. Obviously we will live to see its final stages. As a result, we might see the living planet take the first tentative steps to a comeback. We understand and appreciate diversity in various forms, and members of the community seek to emphasize the attributes that bring us together, rather than those that drive us apart. Indeed, my partners on the property moved to New Mexico's upper Gila Valley specifically because the resident human community is eclectic and accommodating. It's the type of place in which a scientist can find beauty of all kinds, and even create art. The region is a magnet for the likes of me.

As I look out the picture windows of my straw-bale house on an overcast late-winter morning, snowcapped mountains in the nearby wilderness provide a stunning backdrop to the last few sandhill cranes in this small valley. The cranes are among the last to leave their winter home before heading north for an Idaho summer. They remind me that some things are worth supreme sacrifices. Some things are worth dying for, the living planet included. It's not at all clear that my decision to abandon the empire was the right one. I know it will extend my life when the ongoing

economic collapse is complete, and I know it is the morally appropriate decision (as if a dozen people in the industrialized world care about morality). Although Albert Einstein seems to have been mistaken, at least in this case, when he said, "Setting an example is not the main means of influencing others, it is the only means," I will stay the course in pursuit of principle.

My own example has generated plenty of scorn but essentially no influence. On the other hand, the imperialism of living in the city and teaching at a university has rewards that extend well beyond the monetary realm. I miss working with young people every hour of every day. I miss comforting the downtrodden every day, notably in the facilities of incarceration where I taught poetry. And I miss afflicting the comfortable, notably hard-hearted university administrators, at least weekly.

So here I sit, alternately staring at the screen of empire and staring out the window into timeless beauty. I contemplate the timing of imperial collapse and the implications for the tattered remains of the living planet. Half a century into an insignificant life seesawing between service and self-absorption, I wonder, as always, what to do. My heart, heavy as the unbroken clouds overhead, threatens to break when I think about what we've done in pursuit of progress. Spring's resplendence lies ahead, with its promise of renewal. Is there world enough, and time? Will we yet find a way to destroy a lineage 45 million years old, or will the haunting call of the sandhill crane make it through the bottleneck of human industry?

THIS WILD RIVER

Martha S. Cooper

Water is life. How often did we hear that glib statement growing up and not understand its meaning? I spent my childhood in Maine, where water was adequate, even plentiful. My brother and I swam nearly every day in summer. I suppose we sometimes watered our garden. I barely remember.

My first day in New Mexico I walked along Alameda Street in Santa Fe, trying to put my feet down in this new home. Later that evening a colleague said, "Oh, you were walking next to the Santa Fe River." I hadn't seen a river, only a dry gully choked with weeds.

I lived in northern New Mexico for five years and began to understand that water is precious. In the dry air, I noticed my skin cracked. When I backpacked, I planned hikes around creeks. But I did not swim. I wondered if I could stay in this place without water. Years passed. My love for the landscape and people of New Mexico grew deeper.

Eventually I moved to the southwestern corner of the state, an area of sparse population with a relative abundance of water. After years of longing I now swim in the Gila River, every time a miracle to me. On a hot, dry day, easing into the cool river feels a lot like the downpour of a monsoon rainstorm; the water washes away everything else in that moment of immersion. Swimming is the tactile experience of embracing water as life, water as joy. Gulping down a glass of water on a hot and thirsty day also brings awareness that water is life, but my time with the Gila River has allowed me to develop an appreciation for so many other lives beyond my own that depend on water in order to live.

I look down from a mesa at the bright green, wide ribbon of cottonwoods uncurling through Cliff-Gila Valley below, the agricultural area watered by the river where it emerges from the Gila National Forest. I feel a sense of amazement. The mesa, a short sloping distance from the floodplain, is as rocky and dry as is the floodplain soft and rich, the air pungent with the smell of layers of decomposing vegetation. A cacophony of birds chatter to one another, especially when our Central and South American visitors have arrived for the breeding season. Fish hide out beneath the shadows of rocks or tucked up under the banks. Beaver forage and build homes, their teeth marks left behind on willow and cottonwood stumps lining the river's edge. In the distance, cows graze in pastures adjacent to the river, getting fat on irrigated grass. In this land of plenty the river is life, providing for so many winged and scaled creatures, for the breathing cottonwoods that pull up the water and exhale it out into the atmosphere when the day gets hot, even for the cows munching on the grass and wading in the irrigation ditches.

Hiking around the wide floodplain, I began to learn about our wild river, standing on six-foot-high piles of logs and sticks stacked up after floods, getting my boots stuck in low, wet, muddy spots, walking through the bands of willows, alders, seep willows, cottonwoods, and seedy, thistly plants that stretch from one side of the valley to the other. We think of the river as wild when it is running through the confined rocky canyons of the Gila Wilderness, but it is the river itself—both within and beyond the wilderness boundary—that is wild.

Here we encounter black hawks circling with their mates, making seagull-like whistles of alarm, their shadows projected onto the red cliffs behind them. A line of turkeys makes their way single file from the grassy bench next to the river up onto the bank before disappearing into the scrub oak and mountain mahogany. Wolves are seen or heard, for many a definition of wild.

The river remains wild because it has resisted control, despite those who have tried over the past century to nudge it to better serve human needs. It remains an unruly river. The power of the Gila's floods, scooping up sand, gravel, rocks, and trees and then depositing them when the water recedes, as well as the stress of low-flow drought, are forces still exerted on the landscape. Channeled by the narrow canyon in the Gila Wilderness, the river's flood debris is found high up in the adjacent trees. Small wetlands and backwaters are tucked beneath cliffs or behind sandbars, but the canyon limits their expanse. River power is even more evident in the valley, where the Gila tumbles out and spills across, dispersing the force of its flood, with space for it to be both destructive and creative.

As a field representative for The Nature Conservancy, my workdays are spent answering e-mails, reading papers, and meeting with people. But sometimes I take long walks at The Nature Conservancy's Gila River Farm, just a few miles downstream of where the river emerges out of the Wilderness. On one of my early walks to the river, a colleague tried to explain that the channel we were looking at was new, that it used to be far off across the floodplain out of sight from where we stood. In a very big flood in 2005 (35,000 cubic feet per second), precipitated by a lot of rain falling on snow in the headwaters, the river had carved a new course. I listened carefully to this narrative, probably even scribbling down notes, but I lacked the ability to imagine these events. Beneath my feet I could see the barren cobble bars and believe the channel was new. The flood had scoured out whatever vegetation had been there, and not enough time or water had passed for new vegetation to get established. Like this channel I was new to this place. Eventually, after some months of reading about rivers, I decided I should look for that old abandoned river channel across the floodplain.

As I made way, walking in a jagged line through a tangle of tumbleweeds, grass, and chamisa, thrashing through nearly impenetrable willow thickets, sliding down into old ditch or river overflow channels, and smelling the sweet apple aroma of willows, I wondered: what had I been doing trying to learn about the river by reading and sitting in meetings and talking? I needed to get my feet wet and my pants covered in sticky seeds and leaves, and with eyes open try to trace the history of the paths of this wild river, its old and new channels and irrigation ditches. The story of the Gila River, both past and present, is written on the landscape and can be read on foot.

The rich biological diversity and heart-stopping beauty of the Gila River persists because its flood waters still run free, carving out new river channels and overflow channels like the ones I came to discover and explore. Flood waters, as they flow through these channels, seep into the spongelike ground and create wet muddy bars where cottonwood seeds fall, germinate, and grow. Without floods, without droughts, without the unruly, powerful nature of this river, the Gila would be something else, no longer wild.

When I am out walking along the Gila, I see signs of hope: swaths of hundreds of young six-inch-tall cottonwoods with tiny, tender green leaves emerging from the mud; nests of southwestern willow flycatchers tucked in the branches of Goodding's willows; or bright-yellow Wilson's warblers dancing in the willows. The Cliff-Gila Valley, while it bears the marks of human influence in the forms of ditches and levees and poorly designed bridges, is a place that teaches me how arid southwestern rivers were meant to function. With so many reminders of human-caused degradation in

the world around me, and with hours logged in meetings or in front of a computer, I visit the Gila with a feeling of gratitude that this place persists and for what it offers me. Hope. Solace. A deep pool to swim in on a hot day. And I feel equal gratitude for what the river provides for all other living beings that call the Gila home.

CHANGE

Rex Johnson Jr.

According to the Greek philosopher Heraclitus, it is impossible to step into the same river twice.

Rain Creek forms between Mogollon Baldy and Sacaton Mountain, both close to 11,000 feet above sea level. The creek flows south into a canyon that nearly cuts the mountain in half. At its base the creek turns east and tunnels under Rain Creek Mesa, then meets Mogollon Creek down below. As the mesa falls away, Mogollon Creek opens up to the sun and starts to dwindle. A dry wash lined by sycamores finally empties into the Gila River a few miles north of the town of Gila, New Mexico.

I first fished here in 1988. In those days I lived with my wife and four small children in a little white house just above the Gila River, a half-mile off the rough, rutted Turkey Creek Road. There used to be a sign outside Gila that proudly proclaimed: "Gateway to Turkey Creek." My boys all learned to swim in a pool at the mouth of Maldonado Canyon.

I got up before dawn one July morning and drove my old VW bug to Sacaton Road on the other side of the river, another rough road. I climbed above the river and onto Rain Creek Mesa, traveling along the foot of the Mogollons through bunchgrass prairie turned to mesquite and snakeweed. The mesa can be seen from far away; it tilts. After fifteen miles I pulled off the road and got out, climbing down into the canyon where the creek comes out of the mountain. Geologists call this place Mogollon Canyon. Rain Creek is the name of the water.

The summer rains had begun. Everything in the desert had greened up. But it seemed I had arrived too early; I didn't see a single fish in the low light. I followed

the tumbling stream for miles. Nothing. Gloom settled in. I was ready to turn back downstream and climb out of the canyon. Suddenly the sun cleared the towering wall on the east side, and trout appeared everywhere. Where did they come from? Surely they had been there all along. They came from the stream itself. All gloom disappeared; joy shot through.

There were hundreds of fish, drifting effortlessly in schools in the transparent water over sheets of green basalt poured long ago from vents leading to the depths of the earth. Earnest, busy, balanced and graceful, the fish were in their own world within a frail ribbon of clear water sliding down the mountainside. Rain Creek was transformed in front of me, as though I had stepped into a different stream where many other waters flow. The creek had come to life.

I tossed a raggedy nymph in front of one of the trout. It turned its head, swept around, and tried to swallow the little bundle of fur and thread wrapped around my hook. I caught it; let it go. As soon as it escaped my hand, it spotted an insect, a real one, and raced into the middle of the pool to swallow it. I quit fishing early; I'd caught and released exactly 101 trout almost effortlessly. The largest was a little more than one and a half spans of my right hand, about fourteen inches. I climbed out of the deep shade of the alder groves after drinking some of the cold water—surely the best beverage ever invented! Up the side of the canyon out of the shade and into the sun: sun and shade are two critical parts of fishing. I climbed through the oak and juniper, both man and plant struggling to hold onto the side of the canyon, higher and higher, into the overarching blue sky and the blinding sun. After clearing the top, back into view came the mesquite on the mesa; back into view came the desert floor between the high spruce-topped Mogollons and the low juniper scrub Summit and Burros Mountains in the distance. You don't need a map to see it; it's just there: the landscape.

Years passed. I went to fish Rain Creek in the 1990s but only rarely and always downstream. There are falls downstream. You have to climb down, not up. Going downstream, you actually go far below the level of Rain Creek Mesa, a kind of subterranean wandering through hidden forests beneath the plain, going down to where Rain Creek hits the big Mogollon Creek, where there is more water, and then back up Mogollon to the forty-foot falls with its broad, open, somewhat deep and always beautiful plunge pool where it's always possible to catch a seventeen- , eighteen- , nineteen- , or even a twenty-inch rainbow trout.

In those days the land belonged to Rolland Rice, the stern Mormon bishop who often sent hikers back into the Gila Wilderness rather than let them trespass on his family ranch. Rolland's father, Blue, shot the last grizzly bear in New Mexico in the 1930s. Shot it between Rain Creek and Sacaton. It was a mean one, a stock-killer

with two claws missing from an incident with a trap and an old .3030 slug imbedded in its shoulder. It kept charging, and Blue kept putting it down, shot after shot. The bear keep getting up; it came all the way up a mountainside trying to kill the hunter, finally died right at the man's feet; the last one. Old Rolland had his own gun. He scared hikers with it, but he always let me fish at the falls on his land because I used to teach Sunday school at the Mormon Church in Gila. Old Rolland never forgot that, never forgot those days, hardly ever forgot anything.

Then the drought years came. Bad years. I moved away from the Gila. Only memories remained. My boys are grown and gone. My wife and I live in town now. I never made it back up the mountain to fish Rain Creek. But I did go up to Sacaton to look at the Gila trout planted there, way up high, just below the big spring where Rolland said it never dries up. Found them. Caught a really big one, let it go. Found it again the next year. I don't think there are many left up there now. Maybe none. Sacaton is much smaller—not as much water. Might have dried up.

Drought came again, worse than anyone could remember. Even Old Rolland, who always kept a careful watch on the weather for his cows, couldn't remember anything so bad. The heat killed trees along the Gila River, 110 degrees. Forest fires came, bad ones. One burned Lookout Mountain, one scalped Mogollon Baldy, another killed all the trout in Lookout Canyon, another went over the ridge into White Creek and burned the west end of the Diablos, burned up Turkey Creek and killed all the fish. Burned off the whole forest. Rain Creek itself finally dried up. Dried up completely everyone said; no more trout. Gone forever, they said.

The drought ended; water returned. I hiked into the West Fork of Mogollon Creek. Trout still lived in the creek; it had never dried up completely. The West Fork Trail crossed Rain Creek a mile down into the canyon and then climbed a thousand feet out of it, over the saddle and down the other side, into West Fork. I always looked into the water of the forgotten little stream where the trail crossed it and remembered that day in July 1988. I never saw a single fish, just like that earlier morning.

And now, many years later, it has been a wet year with heavy late snows, spring rains too, and it rained all summer. Last year was also a wet year. The rains returned as they always do. The streams are full of water. I went camping with the two Mikes, Mike Gross and Mike Berman, in the Mogollons just like in the old days when we used to go down into the Sierra Madre looking for trout and parrots, *pinabetes* and other such wonderful things, and always found them.

Berman said he had gone almost all the way up Rain Creek and it was full of trout. I went back there a month later in July 2010 and had a look. Not much had changed over the years. There's a new power line leading to the only two ranches at

the foot of the Mogollons. About eight years ago someone chained the mesa to clear the thorny mesquite. Elk used to live on the mesa; don't see many of them now. I think they liked the mesquite, although the cows didn't. Now, instead of part mesquite and part snakeweed, there is nearly all snakeweed and no mesquite. The scraggly weed turns bright green when it rains, giving a false impression of verdure and wealth, but this part of New Mexico is still poor. No one has gotten any richer, in spite of a couple attempts at subdivisions, in spite of someone turning the old Tumbleweed Café in Cliff into an espresso bar, and in spite of the ambitious chaining of all the mesquite on Rain Creek Mesa.

It's turned out that bad drought and enthusiastic overgrazing accomplished what no stock-killing griz could ever do. The Rices sold out after sinking not-quite-so-deep roots into the land for not quite two generations. Sold out and moved out. The fiercely territorial Rolland is now defending a new territory. He's fenced himself into a much smaller patch of this too-small earth. No one can make a real living running cows up here anymore—no way. That life is gone. Gone like the grizzly bear.

Texas money got the Rice place; the falls came with it and so did the trout. Package deal. The same money probably bankrolled the power line, but that money didn't come from cows; it came from something else, something far away from the Gila. A few cows still graze on the mesa, a few new "No Trespassing" signs, including an odd one that says "No Biological Investigations Allowed," can be found, and the new iron gate says "Buckhorn Ranch," but it's not really a ranch anymore. It's more like a summer estate, a large acreage with an "Old West" theme.

The mountains are still here. But that power line is a bad sign. This time I went all the way up the creek, all the way up the shoulder of the ridge between Mogollon Baldy and Black Mountain, way up to the spruce and aspen. Near the top I followed the stream about ten miles to where it splits into twin streams with twin waterfalls. I caught a big trout below each of the falls; each trout just a bit less than two hand spans—seventeen inches. Identical twins. Each leapt out of the water, did flips. Each had broad red bands and yellow bellies. What kind of trout, exactly? I doubt anyone knows. I felt as though I had just awakened from a dream and there they were. Once again, not really knowing any more than I had on that morning twenty-two years ago, I asked myself: "Where did they all come from?" And again there was only one possible answer: they come from the stream, from that same unknown little stream on the backside of the Mogollons—Rain Creek. It's still there.

Trout were everywhere. I've never seen so many, recklessly unafraid the water would ever dry up again, ever. Not afraid of anything. It seemed a little part of me came back to life. No one else was there to see all the colorful trout come gliding

gracefully through the clear water. In fact, it seemed no one had even been up there at all. The old trail, no longer in use, had almost faded away. Fewer people get out these days.

I spent three nights and four days looking up at black clouds threatening rain in the later afternoon, watching fine, powdery, dusty, milky clouds of stars at night, the air clear with the promise of good fishing in the morning. I caught so many fish my flies were shredded. When I returned, I looked at the wrinkled notebook at the West Fork trailhead. A pencil and paper were tied to it. Berman had checked in, maybe three or four others all summer. Someone had seen a bear in the canyon. I wondered if I had seen the same bear. Not a griz of course, but still a big bear. Probably not.

When will I fish Rain Creek again? Maybe I've fished it for the last time. There are so many other streams; you never know when you'll be back. I'm not sure I want to come back again anyway. You never know when a five thousand square-foot "Tuscan villa" or "Cape Cod rambler" might pop up on the mesa, like some giant psychedelic mushroom, a symptom of our collective "profound confusion." No, I don't want to see that; let somebody else look at it. You never know what money will do to a tilted, worn-out mesa. Of course, I'm not going to last forever either, much as I might wish, no matter where I go to fish. Besides, and more importantly, I know for a fact that no one ever steps into the same stream twice.

BOX CANYON ROAD

Sharman Apt Russell

I walk out of my house onto a country road. If I go north three miles, I'll be in the Gila National Forest, 3 million acres of pure southwestern New Mexico: ponderosa pine, piñon pine, scrub-oak, juniper, yucca, prickly pear. These are familiar names and deeply comforting, like beads on a rosary: mountain lion, black bear, elk, javelina, coatimundi, rattlesnake. If I go south four miles, I'll hit Highway 180 and could find my way to anywhere, Dallas or Paris or Bangkok. By God (and here comes my first imitation of Walt Whitman) I live in the best of places! The best of times! My pleasures as democratic as the cloud-tossed sky.

I choose north, low hills of mesquite and shrub brush on my left, the cottonwoods of the Gila River on my right. In thirty minutes of fast walking, I pass one, two, three houses of part-timers like myself whose jobs or family commitments keep us from living in the Gila Valley year-round. It is the bane of country life: how to make money. I pass the dog barking in front of his double-wide, the home of a woman who works for the state highway department. Across the road, a sign reads "War is not the answer," the gate to an intentional community where people live frugally—reducing, recycling, gardening—without jobs. Next to their compound is a rancher whose grandfather worked for the Forest Service here in 1907, when the Forest Service was still a new idea. As the paved asphalt turns to dirt, I pass the driveway of a telecommuting editor originally from New York, an archaeological site (the mounds of a village dating from about AD 500), a grazed-down field with a mule and two horses (perked ears and the slow amble-over), and the barn of someone named Tex.

This is the diversity of the rural West, perhaps of all rural America. Walt Whitman would have put us in one of his lists—poet of the carpenter, the deacon, the duck-shooter, the milkmaid, the stevedore, the crone. We're Baptists and pantheists; we eat beef and drink soymilk; we like wolves and hate wolves; and we're new and old and rich and poor. What we have in common is a feeling that some of us are uncomfortable talking about, and that some of us talk about all the time. We love this place. We are the bride of this place and we are the groom.

The idea is so strange to contemporary culture that we need new words to describe it. The philosopher Glenn Albrecht—who coined *solastalgia* for the pain humans feel when their home environment is degraded or destroyed—is now promoting *soliphilia,* from the Greek *philia* (love of), the French *solidaire* (interdependent), and the Latin *solidus* (solid or whole), meaning "the love of and responsibility for a place, bioregion, planet, and the unity of interrelated interests within it." The term joins *biophilia* (love of living systems, described by psychologist Erich Fromm in 1964 and later promoted by biologist E. O. Wilson) and *topophilia* (from the Greek *topo* for place, used by mid-century poets like W. H. Auden and Alan Watts). When I was a college student majoring in environmental studies in the 1970s, we preferred mouthfuls like *bioregionalism* and *ecopsychology* and the mysterious-sounding *deep ecology*. All these neologisms built on the work of America's first ecophilosophers, Thoreau and Emerson, who, in turn, built on previous philosophers and world cultures. Indigenous voices swell the chorus. In the most modern version, we wonder now if "love of place" is hardwired. Can we find that spot in the brain? Make it light up the PET scan? And, more pertinently, turn it up a notch?

In less than an hour's walk, I'm at the national forest boundary, looking down over fields of prickly pear and mesquite, an undulating rise and fall of land lifting into the rocky hills above the Gila River, rock eroded into giant cones or Stetson hats, and the cliffs rearing beyond them, the rim rock of Watson Mountain pink and orange and white. Then, more grandeur, the bright blue New Mexican sky, a deep azure contrasted with the white and grey of a storm in the distance. My chest feels hollow, as though heart and lungs have evaporated. Within that emptiness, something flowers against the rib cage. A pressure, an ache. That's how I feel my love. This only happens, of course, when I am paying attention.

My body responds physically to the Gila Valley, most often to its expansive views but also down in the irrigated pastures, with the sleepy cows and smell of alfalfa, and by the river with its modest flow, sunlight on water and flap of a heron. Love of place opens me to the beauty of the world, which can be found everywhere, city and suburb, desert and rainforest. A world full of places that people love.

Love of place makes me feel larger. When I open to the world, the boundaries of self, my worries and fears, what makes Sharman happy, what makes Sharman sad, the particulars of childhood and family, talents and flaws, that day in high school, this new pain in my knee—diminish against the lift of land and vault of sky. I'm as big as this view, five miles wide. I'm as powerful as the gathering storm but also calm. Time passes. The river floods and changes everything, and then everything changes again. No worries. No flaws. Nothing is untoward.

I feel grateful. I feel special. And then, because I am so very human and flawed, I feel smug. I'm so cool to live in this place.

The cultural historian Thomas Berry described human consciousness as "the universe reflecting on itself." The Big Bang, birth of stars and planets, evolution of life on Earth, and specifically of *Homo sapiens,* resulted in a woman standing before this view of mountains and clouds. She notes her feelings: calm, blessed, self-congratulatory.

Maybe the universe could have chosen more wisely, but let's not spoil the moment.

I'm in a women's group that meets every six weeks, a kind of play date for the middle-aged. Today we're exploring voice, literally the different noises we can make with our throats and mouths. We've watched the YouTube videos, the exuberant ululation of Darfur refugees and the truly strange Mongolian throat singing—sustained harmonic thrums that represent, with different pitches and tones, particular landscapes. A deep gurgling thrum for the river and forest. A more nasal vibration for the Gobi Desert.

Expectantly, we look to our leader. She suggests we go out into nature and listen. We are sitting on my porch and nature is the immediate yard around my house, irrigated fields below, canopied irrigation ditch behind. It is late summer, a time of year when we get most of our meager annual twelve inches of rain. The desert hills are colored green and the native sunflowers a forest of tall stalks. We disperse, and when we return we each bring back a sound.

One woman begins to duck and whine. Mosquito. Another drops her chin, extends it forward, opens her mouth wide, and blares. Bull frog. Someone tries to buzz like a cicada but lacks the male's drumlike membranes on the abdomen. Someone mimics a lizard rustling in grass. I do a high-pitched do-wop version of the western meadowlark, trying to evoke that jaunty soul feeling if not the actual melody. We use our saliva to imitate water in the ditch. We hum with clenched teeth. Fly. Tongues curl against the roof of the mouth. The *klock-klock* of a raven. We tighten throat muscles. The *skreeeeet* of an insect. We put it all together. We think we sound pretty good.

You laugh—but these women know their world. In their ten or twenty or thirty years here, they have watched the night skies and hiked the trails and banded birds and caught moths for scientific study. They have grown their own food in heat and wind and monitored the habits of foxes and seen the cicada's last molt, that slit in the nymph's skin, the pale adult emerging like some spirit-creature unfurling transparent wings, the creepy brown shell left behind.

Like most humans, they like novelty but not change. They want the weather to be predictable and the birds to keep to their familiar migrations. More personally, they don't want to grow old or have their children leave home. They are searching for wisdom to know when change must be accepted and when it must not. They are looking for ways to live fully in this place.

It's all less wonderful than it sounds. For nearly thirty years, local environmentalists have held off the threat of a dam on the Gila River, successfully preserving the last free-flowing river in New Mexico. Today a major diversion is again being considered, locally and at the state level, with the full support of some irrigators and farmers in the Gila Valley. Love of place doesn't mean we agree about what is best for place.

Moreover, *soliphilia* has its own dangers, no matter your politics or worldview. Love of place can lead to xenophobia, with longtime residents resenting newcomers even (perhaps especially) when they come with good ideas. "Old" or "new" to the rural West, we are all in danger of becoming provincial, caught up in the pleasures of home, and ignoring our connections to the rest of the world. Certainly we can't retreat into our love of the Gila Valley—the descent of sandhill cranes in winter, that golden afternoon light on the fields like some blessing laid over the earth, a hand over our brow, a voice whispering beauty, beauty—and forget about the Gulf of Mexico or Arctic Circle. Toxic chemicals, oil spills, global warming, exotic species. A stab of *solastalgia!* We can't protect our best place without protecting them all.

Box Canyon Road dead-ends at a Forest Service campground on the Gila River, a healthy riparian *bosque* of cottonwood, sycamore, and willow, lime green in spring, emerald green in summer, yellow in fall, gray in winter—not a dull gray, I want to emphasize, but a shimmering luminous evocative gray like the fur of animals or layering of feathers, the gray of twilight in the interstices of branches. (Do I digress yet again? "Logic and sermons never convince," Walt Whitman wrote, "the damp of the night drives deeper into my soul.") Throughout the year, especially on weekends, the campground is well used, and on some weekend walks, when I want to avoid being dusted by cars, I'll turn left after the home of the telecommuting editor onto a second, side dirt road clearly signed "No Trespassing."

Fortunately I have permission to be here, on the private land of my neighbor, the rancher. Regularly we happen to meet, he in his ATV checking stock tanks and gates, and me bipedaling with my day pack, water bottle, and chapstick. He always stops to talk. We always begin with the weather, a subject deeply satisfying to us both. We may stray into matters of personal health or our adult children. At some point, one of us usually says, "Well, it's a beautiful morning," motioning to the nearby sky and grass. We mean something a bit more than this. But that's all we say.

Coming back, I rejoin Box Canyon Road, headed for home now. A mourning dove calls. Perhaps my very favorite sound. A raven *thocks* from the top of a juniper. I think he's *thocking* to me. When I stop, he gets huffy and flaps into the distance, arrowing above the rolling hills dotted with more juniper, mesquite, and scrub brush, black against blue, higher and higher, rising and falling—until he is joined by another raven. Until they disappear and only blue remains. My chest feels hollow.

CONTRIBUTORS

MICHAEL P. BERMAN was born in New York City and lives in the Mimbres Valley in southwest New Mexico. In 1974 he attended Colorado College, where he studied biology and worked with the Peregrine Falcon Recovery Project from 1978 to 1982. He received a 2008 Guggenheim Fellowship to photograph the grasslands of the Chihuahuan Desert. His work is included in the collections of the Metropolitan Museum of Art, the Amon Carter Museum, and the New Mexico Museum of Art, among many. His installations, photographs, and paintings have been exhibited throughout the country. His books include *Sunshot: Peril and Wonder in the Gran Desierto* and *Inferno*.

MARY ANNE REDDING is chair of the Photography Department at the Marion Center for Photographic Arts, Santa Fe University of Art and Design and former Curator of Photography at the New Mexico History Museum/Palace of the Governors. She has published numerous essays on photography and contemporary art. Recent publications include *Through the Lens: Creating Santa Fe* (MNMP) and *Grasslands/Separating Species*.

———————————

CHARLES BOWDEN is the author of eleven books, including *A Shadow in the City: Confessions of an Undercover Drug Warrior; Down by the River: Drugs, Money, Murder and Family; Juárez: The Laboratory of Our Future;* and *Blood Orchid: An Unnatural History of America*. His most recent book is *Murder City: Ciudad Juárez and the Global Economy's New Killing Fields*. Bowden is a contributing editor for *GQ* and *Mother Jones* and also writes for *Harper's, The New York Times Book Review,* and *Aperture*. Winner of a 1996 Lannan Literary Award for Nonfiction, Bowden lives in Las Cruces, New Mexico.

PHILIP CONNORS was born in Iowa and grew up on a farm in southwest Minnesota. He attended the University of Montana and then worked for several years at *The Wall Street Journal* as an editor on the Leisure and Arts page. In 2002 he left the paper for a seasonal job with the U.S. Forest Service in New Mexico. His writing has appeared in *n+1, Harper's,* The *London Review of Books, The Nation*, and elsewhere. His "Diary of a Fire Lookout," which first appeared in the *Paris Review*, was selected for inclusion in *Best American Nonrequired Reading 2009* and became the basis for his first book, *Fire Season: Field Notes from a Wilderness Lookout.*

MARTHA S. COOPER is the Southwest New Mexico field representative with The Nature Conservancy, where she oversees stewardship of the conservancy's Gila and Mimbres Riparian Preserves. Prior to working with The Conservancy, she worked as an outreach and education coordinator for the Rio Puerco Management Committee with the Bureau of Land Management.

DAVE FOREMAN is a former environmental lobbyist and Sierra Club board member and founder of Earth First! He is the author of *Eco-Defense: A Field Guide to Monkey Wrenching*, an instructional manual for direct-action environmentalism.

JORGE GARCIA is a professor at the University of New Mexico. Born in Durango, Mexico, he traces his community back to both where the Mexican wolf survived and to the Aztecs. The Gila cliff dwellings are one of the five places from which he believes his people emerged. He is the vice president of the South Valley Regional Association of Acequias in Albuquerque.

JOHN C. HORNING is executive director of Wild Earth Guardians. He has had extensive campaign and litigation experience working on western water, grazing, endangered species, and land-use management issues. In 2005, the Wilburforce Foundation recognized him with its Outstanding Conservation Leadership Award. A graduate of Colorado College, he has worked as a wilderness ranger for the U.S. Forest Service and as an environmental educator.

REX JOHNSON JR. is a former National Park Service employee who has written three books: *Fly-Fishing in Southern New Mexico; Arizona Trout: A Fly Fishing Guide;* and *The Quiet Mountains: A Ten-Year Search for the Last Wild Trout of Mexico's Sierra Madre Occidental.*

VICTOR MASAYESVA JR. (HOPI) is a photographer and videographer who teaches visual arts in Hotevilla, Arizona. He was selected for a Media Arts Fellowship in 1988 by

the Rockefeller Foundation, which funded his film *Imagining Indians*. He has also received funding from the Ford Foundation and the National Endowment for the Arts. In 1995, Masayesva won the American Film Institute's Maya Deren Award for Independent Film and Video Artists. His book *Husk of Time: The Photographs of Victor Masayesva* was published in 2006.

Guy R. McPherson is a conservation biologist and social critic. He is professor emeritus of natural resources and the environment at the University of Arizona, where he conducted research on global climate change and energy decline. He has authored many books and articles in his field and writes prolifically at his blog Nature Bats Last.

Alex G. Muñoz Jr. is the founder and publisher of *Campfire Legacy Magazine* and *Facepaint*, a New Mexico hunting periodical. With over thirty years' experience, he founded Big Al's Outdoors Adventures, a nonprofit youth hunting organization working with youth to introduce them to the Gila Wilderness.

Mary Katherine Ray, a native of Texas, graduated from New Mexico State University with a biology degree. A lifelong Sierra Club member, she is chair of the Rio Grande Chapter.

Sharman Apt Russell is a widely published essayist and short-fiction writer. Her books include *Standing in the Light: My Life As a Pantheist,* a New Mexico Book Award finalist and one of "Booklist" top ten religious books of 2008; *Hunger: An Unnatural History,* the result of a Rockefeller Fellowship at Bellagio, Italy; and *An Obsession with Butterflies: Our Long Love Affair with a Singular Insect.* Her awards include New Mexico Zia Award, a Pushcart Prize, the Henry Joseph Jackson Award, and the Writers at Work Award.

M. H. Salmon is an avid angler and hunter and the author of nine books, including *Gila Descending: A Southwestern Journey* and the novel *Forty Freedoms.* He is a past member of the New Mexico Interstate Stream Commission and the New Mexico State Game and Fish Commission.

Patrick Toomay, former NFL lineman for the Dallas Cowboys, currently writes for *High Country News* and has published two books: *On Any Given Sunday* and *The Crunch*.

Project editor: Mary Wachs
Design and production: David Skolkin
Composition: Set in Bembo with Trajan display
Duotone separations by Thomas Palmer
Manufactured in Singapore
10 9 8 7 6 5 4 3 2 1

Library of Congress Cataloging-in-Publication Data
Gila / [compiled by] Michael P. Berman.
 p. cm.
 ISBN 978-0-89013-549-5 (slipcase, pb and cloth : alk. paper)
 1. Natural history—New Mexico—Gila National Forest. 2. Gila National Forest—
Pictorial works. I. Berman, Michael P., 1956-
 QH105.N6G55 2012
 508.789—dc23

 2012014323

Museum of New Mexico Press
Post Office Box 2087
Santa Fe, New Mexico 87504
www.mnmpress.org